IMAGES
of America

LOST GERMAN CHICAGO

Joseph C. Heinen and
Susan Barton Heinen

ARCADIA
PUBLISHING

Published by Arcadia Publishing
Charleston SC, Chicago IL, Portsmouth NH, San Francisco CA

Printed in the United States of America

Library of Congress Control Number: 2009927247

For all general information contact Arcadia Publishing at:
Telephone 843-853-2070
Fax 843-853-0044
E-mail sales@arcadiapublishing.com
For customer service and orders:
Toll-Free 1-888-313-2665

Visit us on the Internet at www.arcadiapublishing.com

*To my parents who taught me love
and the premise of holding your past as dear as the present.*

—Susan Barton Heinen

CONTENTS

ACKNOWLEDGMENTS

For my husband and myself, memories and personal history have always been shared around the dinner table with a multigenerational presence. Once the dishes have been cleared, *Kaffee* und *Kuchen* (coffee and cake) served, the photographs appear and stories are shared. Listening very carefully, for nothing was ever written down, you committed the faces and expressions of the photographed faces to memory, retracing every expression and nuance. Along with this would be many questions to the elders. With their answers, the legacy passed on.

Lost German Chicago is a companion book to the Lost German Chicago exhibition at the DANK-Haus Museum. Searches have led to countless avenues and paths leading to people who are willing to share of themselves and their families. It is with great appreciation that we thank the following individuals. Without their help and support, the book and exhibition would not be possible. Their sheer energy and excitement over this project has been encouraging and inspirational! Sincere thanks go to DANK Board of Directors Dagmar Klein Freiberger, James Dombrowski, Joe Matuschka, Susanne Mickey, Angelique Wisler, Scott Will, Tom Diez, Aldalbert Bielski, and Erich Freiberger; Sarah Miller of the DANK Board of Directors and museum collection curator; Albert Schafer; and DANK executive director Nicholle Dombrowski, without whom none of this would be possible.

Additional thanks go to DANK staff Charlie Bills and John Winkhardt with the DANK archive committee, Christine Clark, Mui Baltrunas, and archive and fine art interns Danielle Hammond, Kevin Justiniano, Lily Ahrens, Erin Coleman, Margaret Hankel, Erinne Grant, Erin Shanahan, James Peter Tasch, Bettina Hessler, Amanda Wolfson, and Victoria Carmona.

Ever patient, and simply the best, is our editor, Melissa Basilone of Arcadia Publishing.

Thanks also to Julie Lynch, archivist of Ravenswood and Lakeview Historical Society; Sulzer Library; Theresa Yoder; Marcus Berry of the Harold Washington Library Center; Erin Tikovitsch, a reproduction assistant at the Chicago History Museum; and the Illinois Labor History Society.

Thanks to Lucie Pabel for her generosity in sharing her family's story.

Thanks also to St. Alphonsus Parish, Jennifer Faulk and the Glunz family, the Meyer family, the Schulien family, the Albert Fisher family, Bill and Dorothy Heinen, Barbara and Victor Laurinaitis, Sarah and Martin Hartig, Tony Rizzio, Ludwig Grass for the Philip Grass Collection, David and Ingrid Stalle for the Fries Collection, Joe and Debbie Bradtke, Heinz Freese, Mr. and Mrs. Timothy Vavre, Ellen Meiszner, Heinrich Janssen, Matt Pimprl, Geneveive and Willy Wagner, and to our daughter Elizabeth, whose love, understanding, and flexibility is more than a parent could wish for!

Unless otherwise noted, all images appear courtesy of DANK-Haus Museum.

—Susan Barton Heinen

INTRODUCTION

One historian has noted regretfully that children in Mexico City have more knowledge of the Haymarket Affair than children of Chicago. Another observed the irony that in a city where Germans played such a large part in establishing its educational and cultural institutions, the best-known German artifact is a captured World War II submarine. A turbulent legacy of two world wars has cast a dark shadow, obscuring the memory of the German presence in Chicago. The goal of *Lost German Chicago* is to shed light on the lost history and heritage of the millions of Chicagoans who made up the German community. Although many identified with their regional or provincial principalities, the commonality or bond that held the Chicago German immigrant community together was the German language. For the purposes of this book, we use German to refer to users of the Germanic linguistic tradition rather than the shifting political boundaries of the German States.

German settlement in Chicago centered on the North Side and in smaller enclaves on the South Side, primarily based around the meatpacking industry. The South Side community quickly dispersed, although vestiges of it remained into the 1970s. The North Side, or "Nord Seite," which was heavily populated by Germans, centered near the area of Lakeview. This community pulsated German life, with Lincoln Avenue, its main artery. Germans who arrived here became the most economically successful ethnic group, establishing schools, churches, and monuments. Thinking they were leaving a lasting legacy, their now-derelict churches stand as mute testimonials to values and memories of another time. Standing stripped of their ornamentation, their lifetime was only a few decades longer than the people who erected them.

German immigration peaked in 1890, until stricter immigration policies, combined with a booming German economy, would slow the flow of migrants to a trickle. The German community in Chicago would correspondingly begin to atrophy.

The swinging door of World War II ethnic cleansing brought a small influx of German refugees to Chicago. Leading this new migration were German Jews, intellectuals, and others opposed to the Hitler regime. This ended with the arrival of ethnic Germans from Hungary, Czechoslovakia, and Yugoslavia, who were driven from lands they had inhabited for hundreds of years, thus reinforcing Bismarck's contention that Europe would not have peace "until the tribes were sorted out."

One

BEGINNINGS

Most German immigrants came from lands of small principalities, deeply divided by years of civil and religious wars. This fractious background prevented German Americans from achieving the cohesion as other immigrant groups. Most important political issues of the day found Germans on both sides.

Some of the earliest arrivals were political refugees from the failed revolutions of 1848. Although small in number, they were an articulate intellectual vanguard. They were crucial in modeling immigrant political views. Their critical appraisal of American society compounded building antagonisms with English speakers. These undeniable differences would last for decades. Chicago lacked the established elite of Eastern cities, to whom newcomers owed deference. Germans saw Chicago as a virgin society, where their culture and values were as worthy of dominance as the English. The use of the German language and school funding were recurrent political battles.

Overpopulation and decay of the guild system was the impetus for many of the immigrants. Chicago was changing from an agrarian to an industrial society. This, combined with the devastation of the Great Chicago Fire in 1871, created a huge demand for the skills, building and mechanical trades, that so many Germans possessed. For some young Germans and German Americans, Chicago presented itself as the city of opportunity and as a way station, where men could apprentice from a choice of numerous, already prosperous companies. With these continued apprenticeships they would learn, teach, and move on to their final destination cities to begin plying their trade.

The rudimentary state of Chicago's industries created opportunities that Germans seized to the fullest extent. Over 11 Germans were listed as millionaires by 1890. Concurrently, the forming Chicago Workers Movement, organized by city Germans, reflected socialist ideals banned in Germany.

All these trends found confluence in the Haymarket Affair. Strikers for an eight-hour day, led by German radicals, battled police headed by a German, Capt. Michael Schaack. The resultant trial split Germans along class lines. The workers paper, the *Arbeiterzeitung*, sounded the cry for the defendants' release, while the *Staadtszeitung* and business interests demanded their execution. The decision by Gov. John Peter Altgeld to pardon them effectively ended his promising political career. German American dominance in the skilled crafts trade led them to embrace American style unionism and abandon radical politics. By 1900, the *Arbeiterzeitung* asked, "Where are the German workers?" By 1920, none of the leaders of the Chicago Communist Party bore a German name.

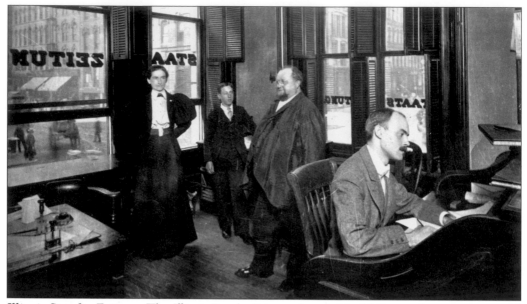

Illinois Staadts Zeitung. The *Illinois Staadts Zeitung*, founded in 1848, was the most successful and influential German-language newspaper. Its strong editorials opposing slavery were crucial in delivering the German vote to Abraham Lincoln. Later in the century, under new owners, the paper became more conservative and waged vituperative battles with German labor newspapers. It ceased publication in 1925.

FREDERICK SULZER. This house was the residence of Frederick, the son of the founder of Lakeview, Conrad Sulzer. The elder Sulzer purchased 100 acres of land and was elected Lakeview's first assessor in 1857. Primarily Germans and Swiss immigrants settled Lakeview. The original impetus for residential development of this area was an attempt by city dwellers to escape an 1854 cholera outbreak, which claimed the lives of over 5 percent of Chicago's population.

CARL SCHURZ. Born 1829 in Liblar, Prussia, Carl Schurz immigrated to the United States in 1852. Becoming a pivotal force in the Midwest Republican Party, Schurz was appointed ambassador to Spain by Abraham Lincoln. Resigning this post in 1862, he entered the Union army, serving as a major general. Leaving this post in 1864, Schurz traveled for Abraham Lincoln as a spokesperson and orator in Lincoln's reelection campaign. This oil painting was proudly displayed at the now defunct Germania Club. Now in the archives of the DANK-Haus, the painting is slated for restoration in 2010.

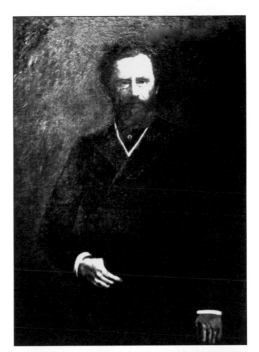

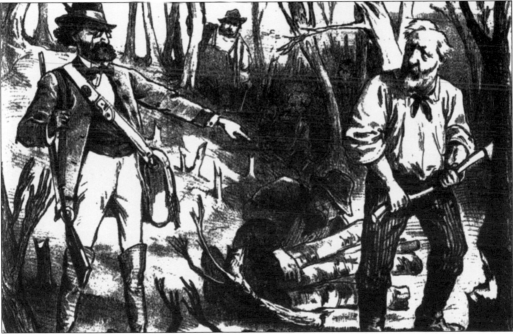

PUCK CARTOON, c. 1878. Founder Joseph Keppler illustrated this cartoon from *Puck* magazine around 1878. This political satire publication was named after the *Midsummer Night's Dream* sprite's observation, "What fools these mortal be." Keppler was a notable German American artist who worked in Chicago during the World's Columbian Exposition and was a member of the Germania Club. This cartoon is of Carl Schurz protesting political insiders despoiling public land without compensation. Schurz was instrumental in delivering the German vote to the Republican Party.

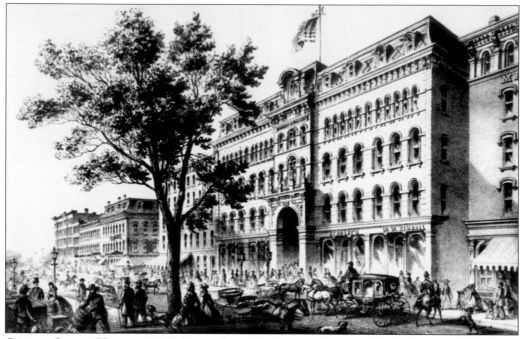

CROSBY OPERA HOUSE, 1865. Located on Washington between State Street and Dearborn Avenue, the building became the premier stage for German opera and talent. Funded with money from Civil War distilling, owner Uranus Crosby invested vast amounts of money, ensuring that his opera house was both opulent in décor and in culture. An astute businessman, Crosby highlighted German opera troops and German opera, marketing "vogue" on all things German to an increasing upwardly mobile German immigrant.

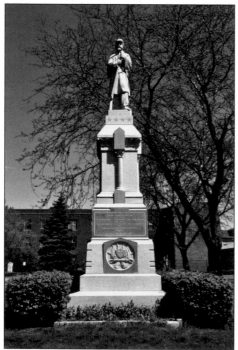

CIVIL WAR MONUMENT. Erected in 1887, this monument is dedicated to the German Civil War soldiers. The monument memorializes some of the 200,000 German enlisted soldiers who served in the Union army. The statue can be found at St. Boniface Cemetery on Clark Street and Lawrence Avenue on Chicago's North Side.

ZUM ANDENKEN. The Civil War monument bears an inscription to the memory of the German soldiers who defended the Union in the Civil War, 1861–1865. An interesting note is that the inscription makes reference to defending the "new Fatherland" or homeland, which the new immigrants fought for.

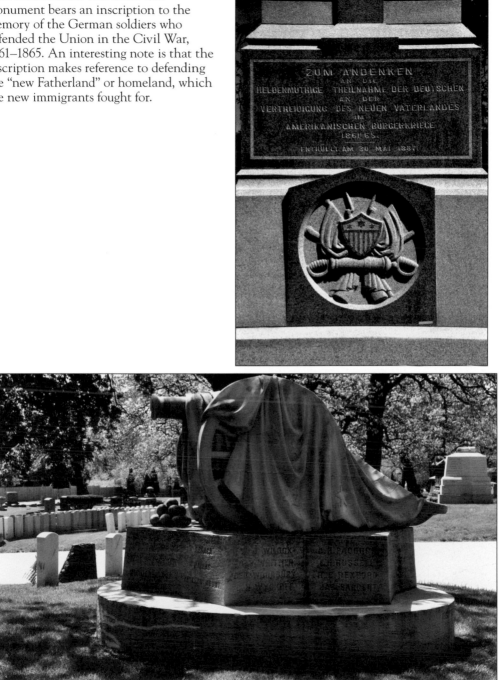

BATTERY A, CHICAGO LIGHT ARTILLERY MONUMENT. Listing all battles that this Chicago unit participated in during the Civil War, this monument by Leonard Wells Volk was installed at Rosehill Cemetery in 1878. The stone draped cannon lists the roster of those who were killed in battle. Volk was also commissioned to design the Stephen A. Douglas monument, which is located at 636 East Thirty-fifth Street, on the city's South Side.

LEONARD WELLS VOLK. Born in 1828 of German descent, Leonard Wells Volk was best known as a sculptor. Arriving in Chicago in 1858, after his many years of studying art in Italy subsidized by brother-in-law Stephen Douglas, Volk asked visiting president Abraham Lincoln in 1860 to sit for a life mask of his hands and face. Lincoln found this process to be "anything but agreeable," but on seeing the completed sculpture, declared it "the animal himself."

BRIEGE ALPINER VEREIN, 1890S. These members of a now-defunct Bavarian social and shooting club, Briege Alpiner, are shown at the Lincoln monument in Lincoln Park. Lincoln and the Unionist cause had an enduring hold on the German psyche. They would often reference it as proof of their unwavering loyalty.

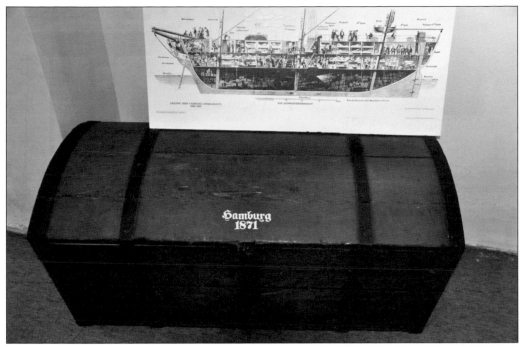

PASSAGE TRUNK. Many Germans emigrated from ports in Germany, France, and England. Hamburg, Bremen, Bremenhaven, LaHavre, and Liverpool were among the most used. This photograph shows an early example of a typical 1871 passage trunk bound to the United States out of Hamburg.

ALBERT FISHER, 1914. Founder of Fisher Body in Detroit, Albert Fisher pays a visit to Chicago while on business. Having apprenticed in the city as a youth at Kimball Carriage on Wabash Avenue in the early 1870s, Fisher continued to frequent Chicago for business purposes. He is pictured here with son Raymond A. Fisher and wife Mary. (Albert Fisher family collection.)

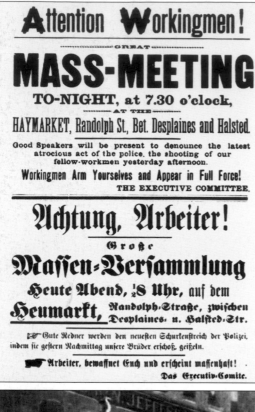

Attention Workingmen!

——— GREAT ———

MASS-MEETING

TO-NIGHT, at 7.30 o'clock,

——— AT THE ———

HAYMARKET, Randolph St., Bet. Desplaines and Halsted.

Good Speakers will be present to denounce the latest atrocious act of the police, the shooting of our fellow-workmen yesterday afternoon.

Workingmen Arm Yourselves and Appear in Full Force!

THE EXECUTIVE COMMITTEE.

Achtung, Arbeiter!

Große

Maffen-Verfammlung

Heute Abend, ½8 Uhr, auf dem

Heumarkt, Randolph-Straße, zwischen Desplaines- u. Halsted-Str.

☞ Gute Redner werden den neuesten Schurkenstreich der Polizei, indem sie gestern Nachmittag unsere Brüder erschoß, geißeln.

☞ Arbeiter, bewaffnet Euch und erscheint massenhaft!

Das Executiv-Comite.

ACHTUNG ARBEITER. The original copy of the flier calling for a rally at Haymarket included the call "Workingmen Arm Yourselves and Appear on Full Force!" August Spies objected and refused to speak at the rally unless that phase was removed. Spies felt that the police were looking to provoke the strikers in order to discredit them. All but a few of these fliers were destroyed and 20,000 revised pamphlets were distributed.

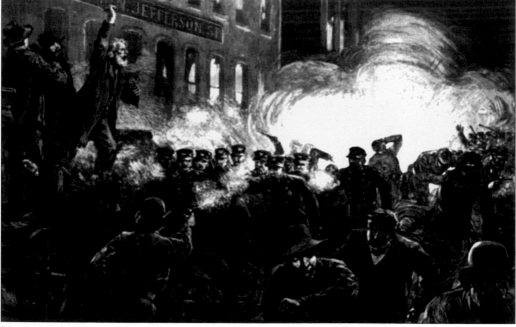

HARPER'S ILLUSTRATION. This is a contemporary depiction of the Haymarket bombing. The rally was organized by mostly German labor organizers to protest the killing of workers by police. The strikers were part of a general strike started on May 1, 1886, demanding an eight-hour day. May Day, celebrated around the world, is in part a commemoration of these events.

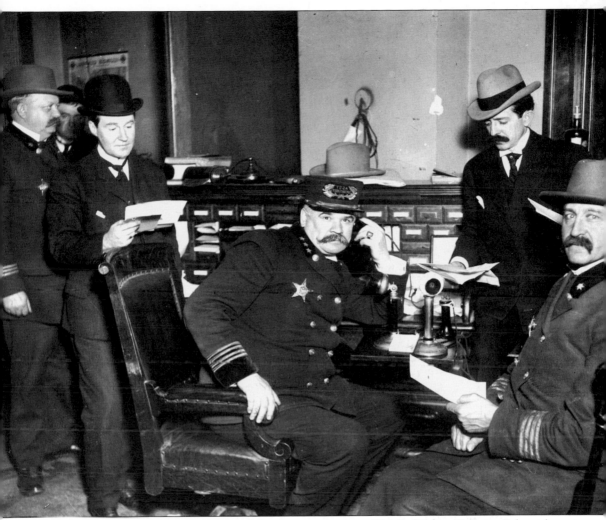

HAYMARKET POLICE CHIEF. A son of German immigrants, Chief of Police Herman Schuettler was a longtime foe of radical anarchists. He made a notable arrest of accused Haymarket bomb thrower Louis Lingg. Trying to resist arrest, Lingg pulled a revolver, prompting Schuettler to bite off one of Lingg's fingers during the struggle. Schuettler also prevented Emma Goldman from speaking during a visit to Chicago in 1908. During World War I, Schuettler helped keep federal heat off the then antiwar Mayor William Hale Thompson by keeping dossiers on local radicals for the FBI. (Chicago History Museum, DN-0003938.)

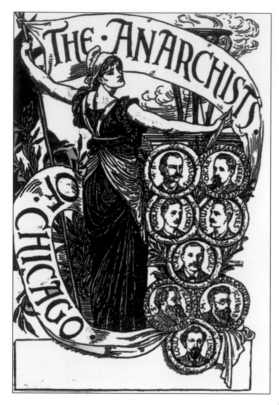

THE CHICAGO ANARCHISTS. Illustrated by English artist and illustrator Walter Crane, this engraving of the eight accused in the Haymarket bombings was widely circulated among labor activists and socialists of the time. Sympathetic to the eight martyred, Crane often traveled to America to speak of their innocence.

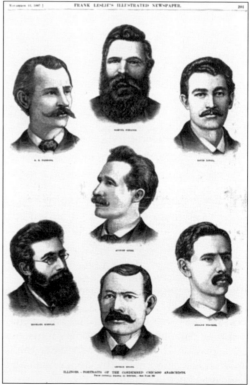

THE HAYMARKET MARTYRS. With eight policemen and at least four workers dead, the Haymarket Affair called for swift justice. Eight attending protestors were arrested, with two additional men indicted but not brought to trial. The day cemented death sentences for seven of the men and a prison sentence of 15 years for the defendant Oscar Neebe.

AUGUST SPIES. Born in 1855, in Landeck, Hesse, August Spies immigrated to the United States in 1872. Learning the upholstery trade in Chicago, he opened his own business in 1876. In 1880, he became a manager at the *Chicagoer Arbeiter-Zeitung*, moving up to editor-in-chief in 1884. Arrested and sentenced to death for the Haymarket bombing, he was hanged in 1887.

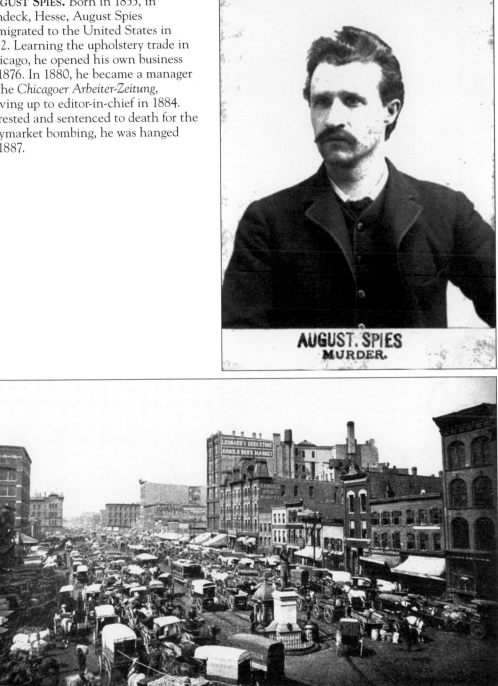

AUGUST. SPIES
MURDER.

HAYMARKET SQUARE, 1890s. The memorial to the policeman killed in the Haymarket bombing remained a magnet for anarchist and leftist attacks, including several bombings during its display on Haymarket Street. After the most recent bombing in 1970, by the 1960s radical group the Weathermen, the statue was removed and put on permanent display in front of the Chicago Police Academy.

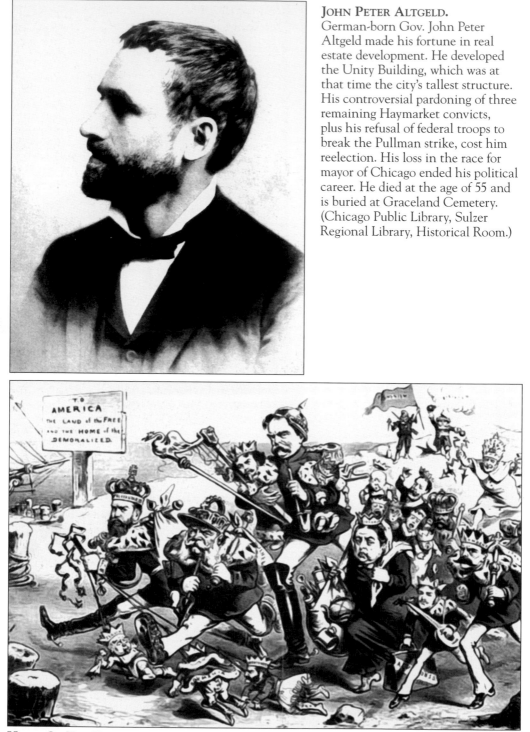

JOHN PETER ALTGELD. German-born Gov. John Peter Altgeld made his fortune in real estate development. He developed the Unity Building, which was at that time the city's tallest structure. His controversial pardoning of three remaining Haymarket convicts, plus his refusal of federal troops to break the Pullman strike, cost him reelection. His loss in the race for mayor of Chicago ended his political career. He died at the age of 55 and is buried at Graceland Cemetery. (Chicago Public Library, Sulzer Regional Library, Historical Room.)

HOME OF THE DEMORALIZED, 1880s. This cartoon from *Puck* lampoons the fear in royalties' ranks, brought on by the socialist and anarchist movements. In fact, it was the anarchists who caught the boat to America, chased by Bismarck's antisocialist laws.

GENERATIONAL ASSIMILATION. On the path to assimilation, these are wedding photographs from two generations. The couple at right emigrated from Trier, Germany, in 1880. Like many German immigrants, he was an artisan working as a stonemason. German was exclusively spoken in the home until it became an impediment to their children's academic success. After that, English was only spoken in the home. Ironically, while avoiding Germany's seven-year military obligation was the prime reason for Matthias Heinen's exodus, the three succeeding generations would all have members drafted into the U.S. Army. During World War I, members of the bride's family, shown in the photograph below, would Anglicize their name to Kehrer from the Germanic spelling of Kahrer.

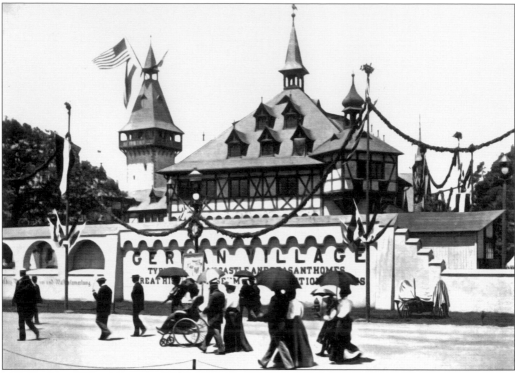

THE GERMAN VILLAGE, 1893. The German village at the World's Columbian Exposition offered customers a chance to get a bite and have refreshments in a re-created German beer garden and town. The beer garden was so popular that after the fair investors built a park modeled after it. Named San Soucci, after the kaiser's estate outside Berlin, this beer garden became one of Chicago's first amusement parks.

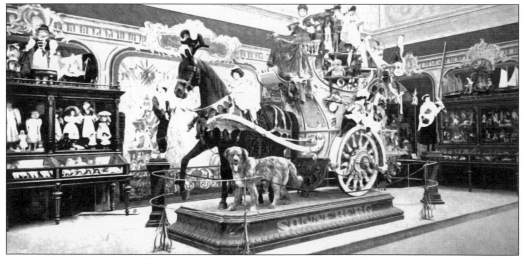

SONNEBERG TOYS, 1893. Known for its toy manufacturing, Sonneberg, Germany, introduced at least 10 separate toy makers from that region at the World's Columbian Exposition of 1893. About 70 percent of the town's income came from the production of dolls, especially the manufacture of dolls with jointed limbs. Premiering some of the finest toys and new toy-making techniques to Chicago and the United States, the Sonneberg toy exhibition was widely popular.

THE GERMAN BUILDING, 1893. Pictured here are the front and rear views of the German Building at the World's Columbian Exposition in 1893. It was one of the few permanent structures erected at the fair. The rear gardens provided visitors with welcome relief from the summer sun and heat. After the fair's completion, the building was a popular Jackson Park restaurant until it was destroyed by fire in 1925.

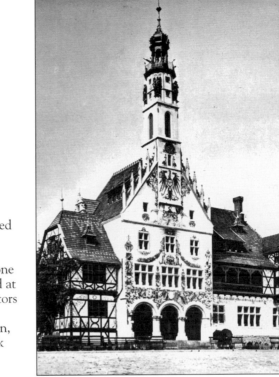

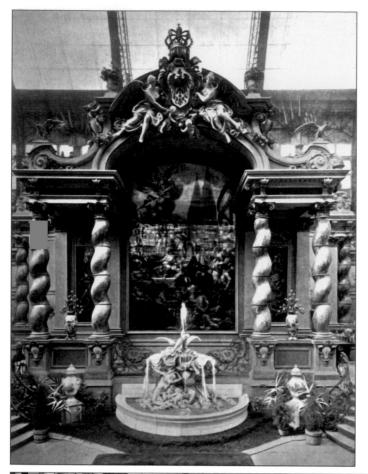

THE PORCELAIN PORCH, 1893. This imposing edifice, called the Porcelain Porch, was located in the German section of the Manufactures Building at the World's Columbian Exposition. The Royal Porcelain Factory of Berlin produced the entire structure. The 18-foot center tile section, along with the side colonnades, were later relocated to the Germania Club where it was renamed, "The Glory of Germania." As the centerpiece of the club's ballroom, it often served as the backdrop for choral expositions. It remained at Germania until the club disbanded in 1986. Although the club valued the piece at over $1 million, it was unable to find a suitable new location and owner. The structure currently lies dismantled in storage, awaiting its final disposition.

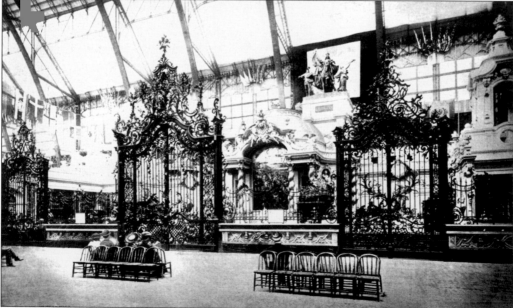

BLACK FOREST HOUSE, 1893.
In 1893, over 235 Bavarians were sent to the World's Columbian Exposition, where they staged the Oberammergau Passion Play. Shown here are some of the men in front of the Schwartzwald Haus, or Black Forest House, located within the German village. Over 65,000 pieces were shipped to Chicago from Germany and reassembled to create the 17,000-square-foot village.

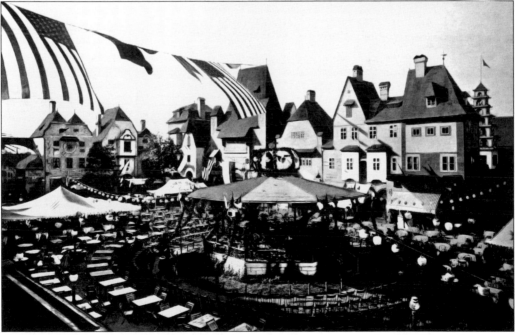

AUSTRIAN VILLAGE, 1893. One of the most popular venues at the 1867 Paris Exposition Universelle was the Austrian restaurant and café. Rebuilding a much larger venue in Chicago, the Austrian village of the 1893 World's Columbian Exposition featured open-seating beer gardens and cafés.

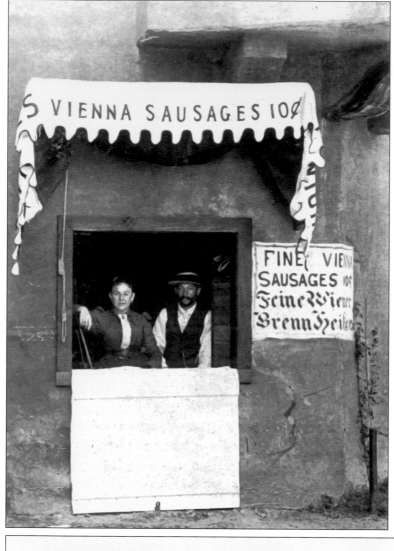

VIENNA SAUSAGE, 1893. This is a picture of two Austrian food vendors at the World's Columbian Exposition of 1893. Whatever else, the exposition was not cheap, as evidenced by the 10¢ sausages. This particular stand took place inside the Vienna or Wien complex. The World's Columbian Exposition provided several local German sausage companies with their first national exposure. Austrian immigrants Samuel Ladany and Emil Reichl sold their products from concession stands. German immigrants Oskar and Gottfried Mayer also sold their products and sponsored events during the fair. The particular advertisement dates from the 1920s.

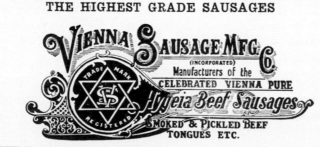

Two

RELIGION
AND EDUCATION

Promise of a new life for German emigrants to the New World came fraught with struggles and uncertainties. While freedom of religious expression was the goal of some, the prime motivator for the almost seven million German immigrants was the allure of a better life in America and escape from the economic privations at home.

Unfamiliar to the native language and customs of their New World, many of the German immigrants suffered exploitation. They flocked to ethnic enclaves in their new city of Chicago. In an age where American government social services were minimal, German religious organizations provided many welfare functions. Ethnic churches became the entry port where immigrants could be introduced to a community where they could find immediate food, shelter, and clothing. Coming from a society with more government social services, German churches were attuned for need of welfare intervention. Many institutions were formed in reaction to the massive influx of German immigration and the specific needs they posed. The Great Chicago Fire of 1871 left countless people homeless, orphaned, and in need of medical assistance. Private German charities accepted and assumed responsibilities needed for the provision of those left destitute. Chicago's German Jews founded institutions such as Michael Reese Hospital to replace the destroyed Jewish Hospital. They also founded the B'nai Brith lodges Germania and Teutonia. These secular Jewish lodges provided aid and help to their fellow immigrants.

Education also became a core focus of religious institutions. Maintaining and preserving the language of Luther was of paramount importance to the Lutheran church. Catholics suspicious of Protestant influences in school curriculum led to establishing private schools, which allowed greater flexibility in education by teaching in the native language, introducing cultural nuances and distinctions regarding citizenship, all while ensuring that their pupils were cared for in an extended German Catholic community.

Milestones of life were always experienced and recorded through the church. With baptisms, marriage band and vows, and last rites and eulogies, the church was the epicenter of German life. However, with the passage of time, changing attitudes, and demographics of neighborhoods, many German founded churches have been sold, neglected, or demolished. Within the balance lies the fate of St. Boniface Church. Granted a stay in February 2009, the church awaits its final disposition. Standing in silence, one can hear the echoed voices within the abandoned church and trace the worn and fading dedication at the cornerstone of the structure.

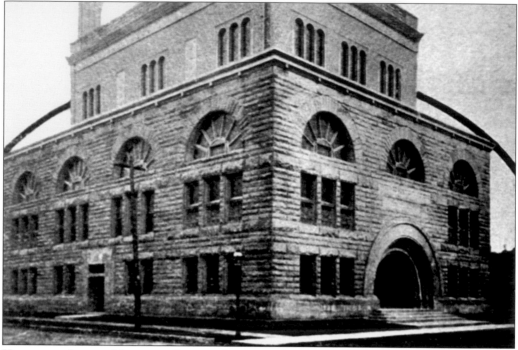

KEHILATH ANSHE MAARAV. German Jews, mostly from Bavaria, organized Chicago's first Jewish congregation in 1847. They moved to their structure at Thirty-third Street and Indiana Avenue in 1870. Dankmar Adler, who emigrated from Germany to Chicago via Detroit, designed the building. Adler's father, Liebman, was the rabbi there for many years. The congregation sold the building when it moved south into Hyde Park. Since 1922, the building has been home to the First Pilgrim Baptist Church. Adler's partner, Louis Sullivan, designed the intricate motifs for which the temple was famous. It was designated a historic landmark in 1981. The building was almost completely destroyed by fire started during roofing repairs. The ruins have been propped up awaiting final decision on its fate.

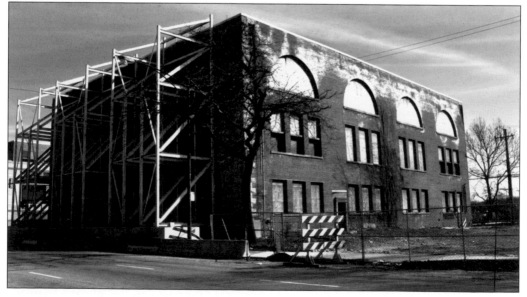

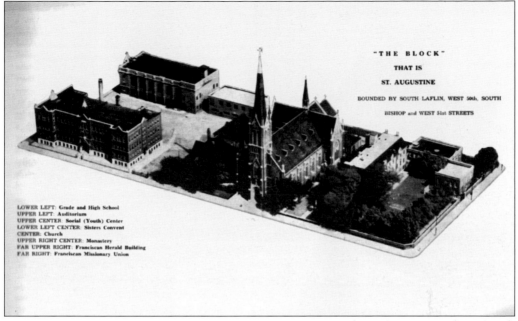

"THE BLOCK"

THAT IS

ST. AUGUSTINE

BOUNDED BY SOUTH LAFLIN, WEST 50th, SOUTH

BISHOP and WEST 51st STREETS

LOWER LEFT: Grade and High School
UPPER LEFT: Auditorium
UPPER CENTER: Social (Youth) Center
LOWER LEFT CENTER: Sisters Convent
CENTER: Church
UPPER RIGHT CENTER: Monastery
FAR UPPER RIGHT: Franciscan Herald Building
FAR RIGHT: Franciscan Missionary Union

AERIAL VIEW OF ST. AUGUSTINE, 1930S. St. Augustine was a large German-speaking South Side parish. By its completion, it occupied an entire city block including a school, social center with bowling alley, clergy housing, church, and even a credit union. In accordance with Cardinal George Mundelein's edict, it switched to an English liturgy in 1916.

POOR HANDMAIDS. The Poor Handmaids of Jesus Christ were a nursing and teaching order that originated in Germany. Brought to Chicago by a burgeoning German community, the order staffed the Municipal Isolation Hospital, which treated smallpox patients, and Angel Guardian Orphanage. Language barriers sometimes led to misunderstandings between the German nuns and those they served. One patient asked a nun for her husband. The sister had never heard that word before, but deduced that *hus*, meant "hose" and that *bund* meant "band." Therefore, she decided that the patient wanted her garters. The patient was startled to hear that her husband was folded up and put in a drawer.

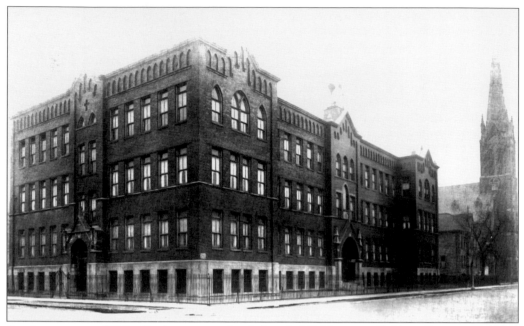

ST. AUGUSTINE, 1930S. St. Augustine school, founded 1884, was staffed by a German teaching order of nuns. The Poor Handmaids of Jesus Christ began educating the youth of the growing parish. Starting with 140 students at its inception, it grew to a peak of over 1,200. Catherine Kaspar founded the Poor Handmaids Order in Germany in 1851.

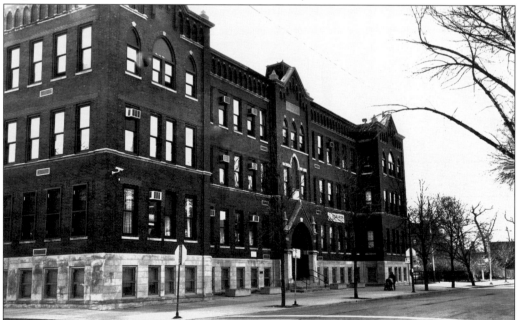

ST. AUGUSTINE, 2009. The South Side German community lost its cohesion fairly rapidly. By the 1930s, prosperous middle-class Germans began leaving the South Side neighborhood for opportunities elsewhere. The school and church continued to serve a diverse ethnic community until the school was closed in the 1980s, followed soon after by the church in 1990. The old school is now operated by the board of education as a public school.

FIRST COMMUNION, 1920s. Shown here is one of the many German American children who passed through St. Augustine school and church in his first communion photograph. These children were predominately taught in German until Cardinal George Mundelein established uniformed English instruction throughout the Catholic schools in 1916. For some children, this instruction was an education solely based in a language that was not spoken in the home.

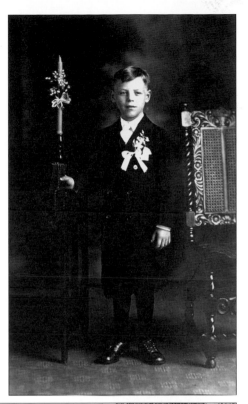

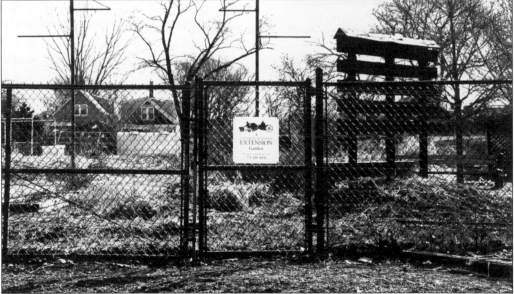

EXTENSION GARDEN, 2009. The spot where St. Augustine parish once stood is now a community garden created from grant money supported by the City of Chicago Department of Environment along with volunteer staffing from the University of Illinois Extension. The garden plot produces vegetables given to Women, Infants and Children (WIC) food centers in Chicago. Like many city parishes, St. Augustine fell victim to changing neighborhood demographics, increasing costs of maintaining an over-century-old structure, and declining levels of religious observance.

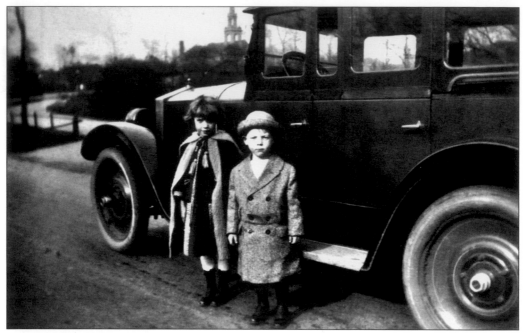

BACK-OF-THE-YARDS, 1930s. These two German American children pose in front of their family car by Sherman Park on Fifty-fifth Street. In the distance are the twin towers of St. John of God, a Polish Catholic Church designed by German American architect Richard Schlacks. Dressed in their Sunday best, the children have just come from St. Augustine Church; a German speaking Catholic parish located a few blocks away at Fiftieth Street and Laflin Avenue.

ST. JOHN OF GOD, 2009. This Schlacks church is located at Fifty-second Street and Throop Avenue across from Sherman Park on the city's South Side. St. John was the home parish of Fr. Louis Grudzinski, one of Cardinal George Mundelein's chief opponents. Portions of the St. John of God's complex are still in use, but the church is now defunct and boarded due to post–World War II loss of parishioners to the suburbs.

DAUGHTERS OF CHARITY. A Daughter of Charity nun, Sr. Walburga Gehring came to Chicago in the mid-1860s after the Civil War. After nursing both northern and southern soldiers of the Gettysburg battlefield, attentions of the order were focused toward larger cities like Chicago. The Daughters of Charity founded St. Joseph's Hospital on Garfield and Burling Avenue to accommodate increasing immigrant numbers and the specific epidemic and health issues they presented, such as cholera and smallpox.

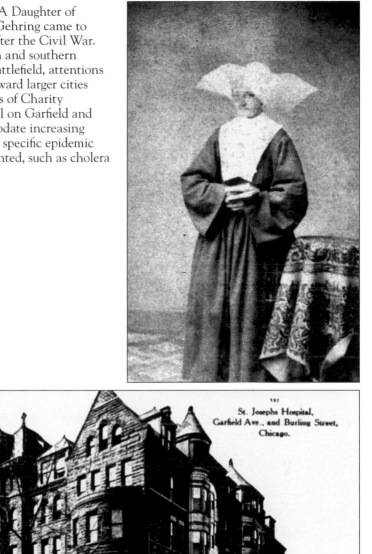

St. Josephs Hospital,
Garfield Ave., and Burling Street,
Chicago.

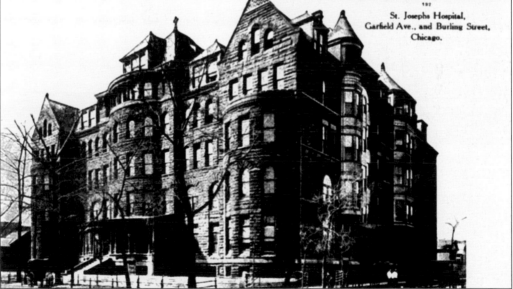

ST. JOSEPH'S HOSPITAL. Sr. Walburga Gehring became a supervisor of St. Joseph's Hospital, helping the more than 50,000 new immigrants pouring into the city each year. In 1881, she was asked by the Archdiocese of Chicago to open a new hospital to accommodate destitute mothers and parentless children. She opened the St. Vincent's Infant Asylum in a small rented building at 1100 North Orleans, and within the span of one year, had outgrown the building due to the increasing needs of the community they served.

ANGEL GUARDIAN ORPHANAGE. Established in 1865 and staffed by the Poor Handmaids Order, Angel Guardian Orphanage was organized by five German Roman Catholic parishes. Ensuring that dependent and needy children be raised within a German cultural milieu was the prime motivation for its founding. The orphanage operated until 1974. It is now the Misericordia Home for special children, located on Ridge and Devon Avenue.

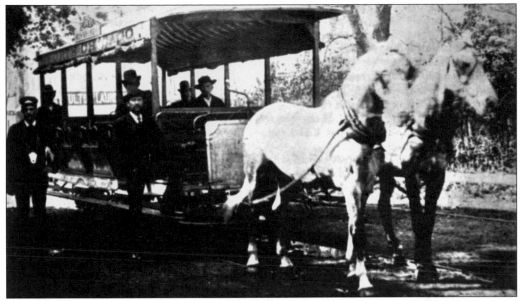

STREETCAR, 1900. This horse-drawn trolley ran down Lincoln Avenue. It was the only public conveyance for Lakeview's German Catholics to get to St. Michael's in Old Town. The distance and hardship of the journey were the impetus for building a new German Catholic Church, St. Alphonsus. (St. Alphonsus collection.)

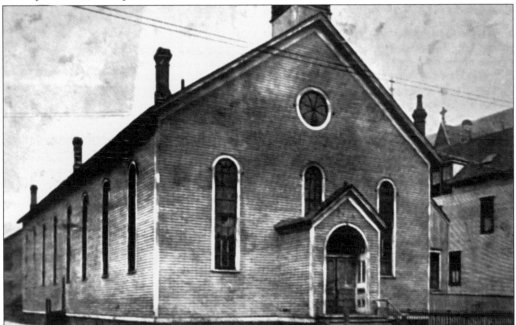

ST. ALPHONSUS CHURCH, 1882. In 1882, the newly organized St. Alphonsus parish paid $9,000 for five acres of land bordering Southport, Wellington, Oakdale, and Greenview Avenues. A 150-foot-by-50-foot frame church was constructed for the parish. On September 3, 1882, the congregation celebrated its first mass in the new wooden structure. Given in the native tongue of German, the first mass cemented a tradition of one mass being held in German at the parish even to this day. (St. Alphonsus collection.)

FIRST RECTORY ST. ALPHONSUS. The original rectory served the congregation until 1925, when it was replaced with the current building. It stood on what is now the Athenaeum Theater. (St. Alphonsus collection.)

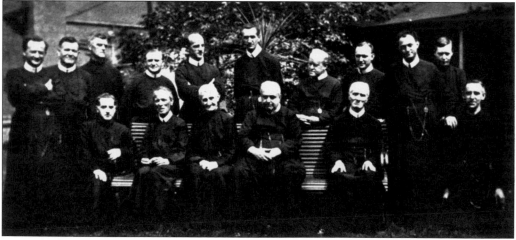

EARLY PRIESTS, 1900. St. Alphonsus was the last Catholic church holding services in German. They were recently discontinued. There are still four Lutheran congregations that hold a German service. The Redemptorist Order turned over control of St. Alphonsus to the archdiocese in 2000. (St. Alphonsus collection.)

ST. ALPHONSUS SCHOOL, c. 1896.
This *c.* 1896 photograph shows a girls'
music class at St. Alphonsus. The school
began in 1882 with 70 students. The
children were instructed in German
by the Sisters of Notre Dame, who
oversaw their instruction until 1997.
The original wooden structure was
replaced with a large, brick structure
in 1906. At its peak, St. Alphonsus
School had 1,600 students.
(St. Alphonsus collection.)

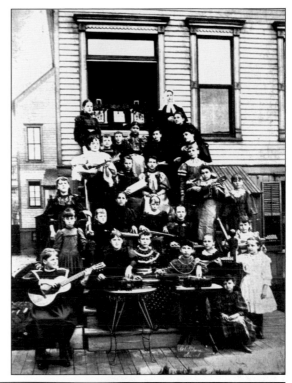

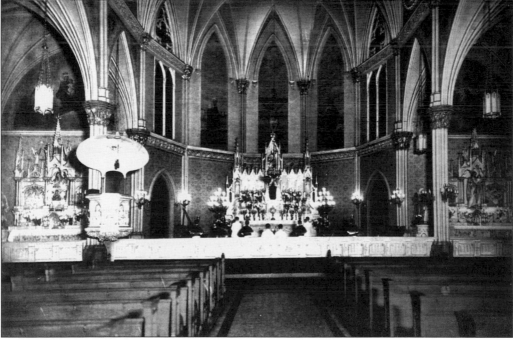

MAIN ALTAR, 1934. This photograph shows the original interior and altar of St. Alphonsus.
The current larger and more ornate back altar was installed after World War II. Missing
also from today's altar is the covered half shell lectern and the two smaller side altars.
(St. Alphonsus collection.)

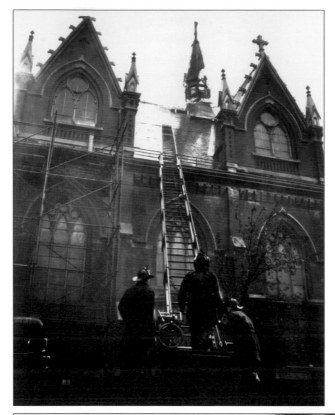

ST. ALPHONSUS, 1950. A fire, which started on the newly repaired roof of St. Alphonsus, caused severe damage to the church. Heroic efforts by the fire department saved much of the church's treasures. Although no firemen were seriously injured, five fell 12 feet when part of the roof collapsed. (St. Alphonsus collection.)

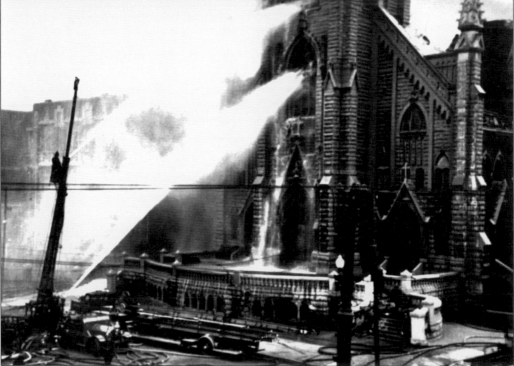

THE AFTERMATH, 1950. The final extent of the damage is shown in this photograph dating from 1950. Most of the Munich stained-glass windows were salvaged as was well as the recently installed new altar. The organ, which was valued at $30,000, was completely destroyed. Officials said that the fire started near the choir loft where the organ was housed. (St. Alphonsus collection.)

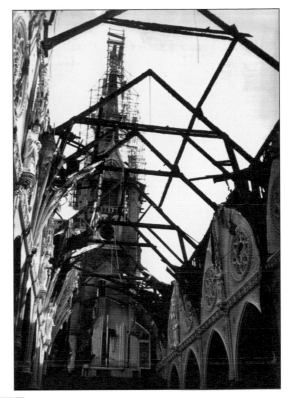

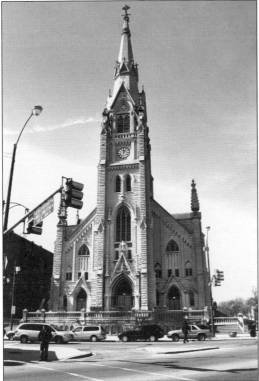

ST. ALPHONSUS, 2009. The Redemptorists were a German missionary order. As the burgeoning community outgrew nearby St. Michael's parish, both parish and priests realized the need for a second German-language church and school. They opened their second church, St. Alphonsus, named for the patron saint of their order.

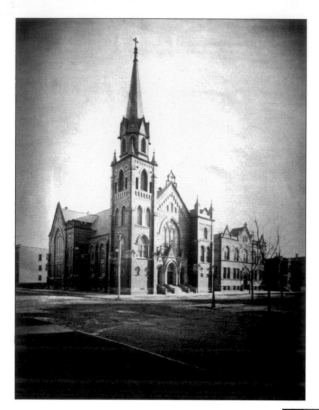

ST. JOHANNIS. Organized in 1867, St. John's was originally known as Ev. Luthernische St. Johannis Kirche. It was the fourth Lutheran congregation in Chicago and was part of the German-speaking Missouri Synod, which itself was organized in Chicago in 1847. The Lutheran church was so thoroughly German that by the 1880s, there was only one English-speaking congregation in the city.

ST. JOHN'S, 2009. This structure was erected in 1906 to replace the original wooden church. In general, Lutheran churches were more successful than Catholic churches in adapting to changing neighborhoods. St. John's parish and school closed in the early 1970s. The church is currently for sale.

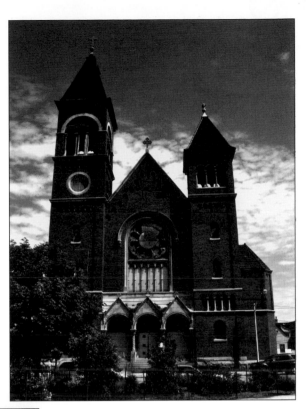

GERMAN LEAGUE OF CHURCHES.
Henry Schlacks was one of the most
talented and prolific church architects
in the city of Chicago. He built 5
churches for the German League of
Churches and 12 churches in all. The
German League of Churches was
comprised of 35 parishes in the city
of Chicago.

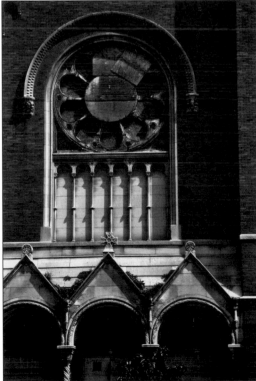

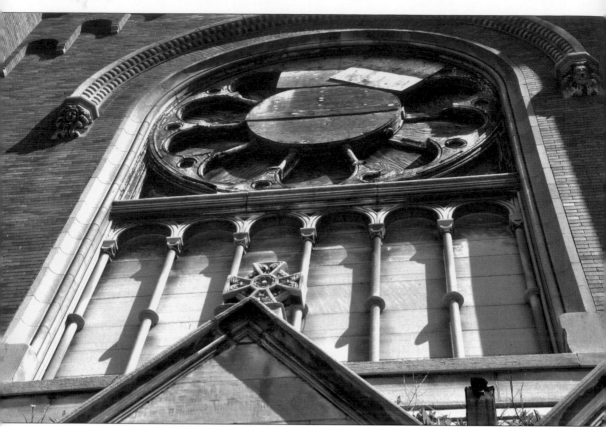

St. Boniface, 2009. St. Boniface on Noble Street was one of the oldest German parishes in the city, having been organized in 1861. While many of Schlack's churches are still operating, St. Boniface fell victim to archdiocese closings. The Romanesque-style church stands vacant waiting to be razed.

Three

BREWING AND THE CHICAGO KULTURKAMPF

Just as the second building that the Puritans erected in New England was a brewery, one of the first buildings in Chicago by German immigrants William Haas and Conrad Sulzer was a brewery. The brewing of beer and how and when it was consumed was to be integral to the Germans' experience in Chicago and their relations with the English community. The Germans brought new technical expertise, brewing a new preferred lighter lager, which enabled them to become the dominating force in the brewing industry. This brought great wealth to the city. By 1900, one-fourth of Chicago's revenues were derived from the alcohol industry.

Prohibitionists were convinced that nothing but evil came from a glass of beer. The Anti-Saloon League and the Women's Christian Temperance Union fought a 70-year running battle with the brewing interests. Utilizing a well-funded political war chest, the beer and liquor industries were able to fend off the dry forces. One brewer was indiscrete enough to say that he defeated the Women's Christian Temperance Union three times. Intermixed in this brew were underlying cultural antagonisms between Germans, other predominately Catholic beer-drinking immigrant groups, and the host society. The Germans, who appeared to disregard the Sabbath as they spent Sundays in beer gardens, outraged religious English speakers. Their boisterous parades marched past churches during services, infuriating the congregants.

The enforcement of Sunday closing laws, which Germans interpreted as an attack on their culture and on their only day of rest, was a continued contentious political issue. In 1854, the heated argument erupted in violence in the Lager Beer Riot, when a large armed group of enraged Germans and Irish allies marched on the County Building. In the ensuing melee, one person was killed, scores injured, and over 60 arrested. Unofficial accounts put the dead much higher.

After that, political disputes would be settled at the ballot box, but nativists would always see an attack on beer consumption as a blow against what they saw as the un-American tendency in the German community and preserving their English cultural hegemony.

Prohibition forces were finally able to use the anti-German climate during World War I to enact the 18th Amendment. Following repeal, the Chicago brewing industry slowly succumbed to the better funded, organized national brewers. The lingering death rattle concluded with the closing of the Meister Brau Brewery in 1978, ending a 140-year tradition of German brewing in Chicago.

L. D. Boone

THE BEER RIOTS. Levi Boone was elected mayor in 1855, on a know-nothing platform of nativism and prohibition. His Sunday tavern closings ignited a bloody melee known as the Lager Beer Riot when an angry mob of German and Irish Chicagoans tried to march on the County Building. They were repulsed after an armed conflict with police that left one dead and scores injured. (Chicago Public Library, Sulzer Regional Library, Historical Room.)

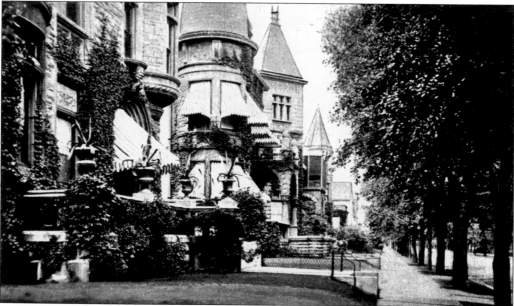

LINCOLN PARK STREET, 1900S. Success in business left many Germans with the wherewithal to live in these solidly upper-middle-class homes. This picture is of a street off Fullerton Avenue in the predominately German Lakeview neighborhood. By the dawn of the 20th century, many established Germans owned sizeable firms that employed the newest wave of immigrants.

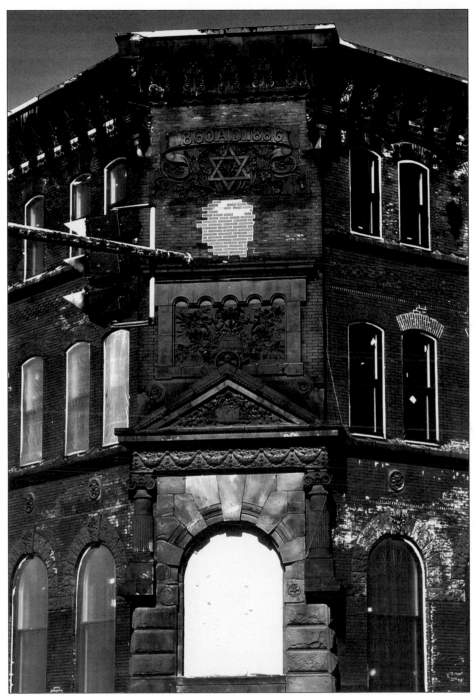

SCHOENHOFEN BREWERY, 2009. This building at West Eighteenth Street and Canalport Avenue is the oldest of a complex that stretched over several city blocks. The Schoenhofen Brewery is often misidentified as an old synagogue because of the six-pointed star, a symbol that has been used by German breweries since the Middle Ages as a sign of purity. After years of standing vacant, the building is being renovated. The 1860 date on the facade refers to the founding of the business at another location.

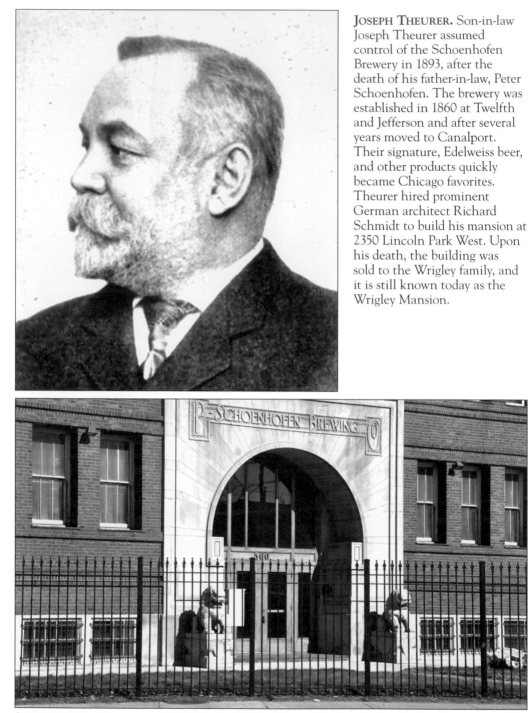

JOSEPH THEURER. Son-in-law Joseph Theurer assumed control of the Schoenhofen Brewery in 1893, after the death of his father-in-law, Peter Schoenhofen. The brewery was established in 1860 at Twelfth and Jefferson and after several years moved to Canalport. Their signature, Edelweiss beer, and other products quickly became Chicago favorites. Theurer hired prominent German architect Richard Schmidt to build his mansion at 2350 Lincoln Park West. Upon his death, the building was sold to the Wrigley family, and it is still known today as the Wrigley Mansion.

SCHOENHOFEN COMPLEX, 2009. Richard Schmidt was hired to design this building, one of the last in the Schoenhofen complex. It is noticeably more modern in appearance. The Schoenhofen brewery remained a local operation, except for a period in the 1890s when it was acquired by an English syndicate, and in 1918, when the federal government seized it due to the family's continued correspondence with friends and family in Germany.

EDELWEISS BEER. Schoenhofen was one of the more successful local breweries. Established in 1860, besides its Edelweiss brand, it also made a local Chicago favorite soft drink, Green River. Drewry's acquired Schoenhofen in the early 1950s, thus ending another German-established local brewery.

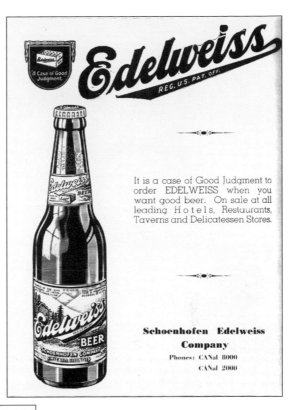

It is a case of Good Judgment to order EDELWEISS when you want good beer. On sale at all leading Hotels, Restaurants, Taverns and Delicatessen Stores.

Schoenhofen Edelweiss Company
Phones: CANal 8000
CANal 2000

THE FINEST
MALT *and* HOP BREW

Edelweiss Brew—the modern brew with the old-time taste is the most popular drink among patrons of hotels, clubs and restaurants. People call for it because it adds a familiar zest and sparkle to luncheons and dinners.

For new patrons, suggest Edelweiss Brew as a special treat—they'll be more than delighted; for old, have it ready to serve at all times.

SCHOENHOFEN COMPANY : CHICAGO
Have you tried Edelweiss Lime Rickey?
Delightful by itself or mixed.

SCHOENHOFEN BREW, 1920S. Trying to survive in the parched climate of Prohibition, and anticipating modern N.A. (no alcohol) beers by seven decades, many breweries tried offering nonalcoholic beers. Marketed to look like regular beer, this Schoenhofen product is referred to as brew.

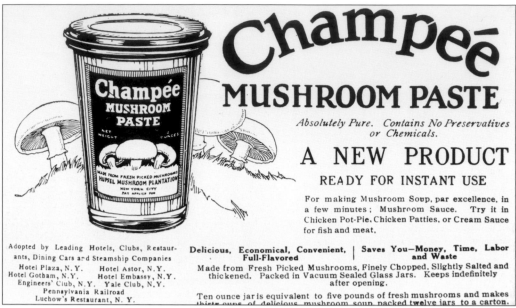

Champée
MUSHROOM PASTE

Absolutely Pure. Contains No Preservatives or Chemicals.

A NEW PRODUCT
READY FOR INSTANT USE

For making Mushroom Soup, par excellence, in a few minutes ; Mushroom Sauce. Try it in Chicken Pot-Pie, Chicken Patties, or Cream Sauce for fish and meat.

Adopted by Leading Hotels, Clubs, Restaurants, Dining Cars and Steamship Companies

Hotel Plaza, N.Y. Hotel Astor, N.Y.
Hotel Gotham, N.Y. Hotel Embassy, N.Y.
Engineers' Club, N.Y. Yale Club, N.Y.
Pennsylvania Railroad
Luchow's Restaurant, N.Y.

Delicious, Economical, Convenient, Full-Flavored | Saves You—Money, Time, Labor and Waste

Made from Fresh Picked Mushrooms, Finely Chopped, Slightly Salted and thickened. Packed in Vacuum Sealed Glass Jars. Keeps indefinitely after opening.

Ten ounce jar is equivalent to five pounds of fresh mushrooms and makes thirty cups of delicious mushroom soup, packed twelve jars to a carton.

CHAMPEE MUSHROOM PASTE, 1920S. Challenged by the new restrictions of Prohibition, the Schoenhofen Company became the Illinois distributor of New York City–produced Champee Mushroom Paste. By expanding its business through the distribution of food products, the Schoenhofen Company creatively kept the business engaged with high-end hotels of Chicago and New York City. The new product promoted a new "ready-for-instant-use . . . convenient . . . economical . . . delicious" mushroom paste, sure to become an "inexpensive delicacy."

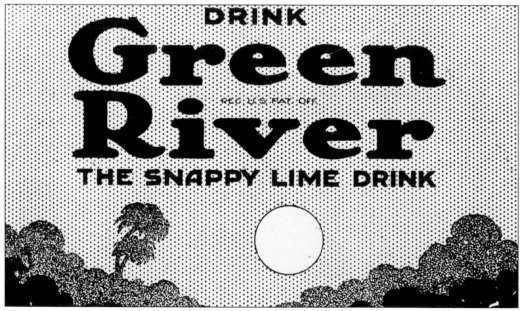

DRINK
Green River
REG. U.S. PAT. OFF.
THE SNAPPY LIME DRINK

GREEN RIVER. Many local breweries creatively produced and manufactured numerous nonalcoholic products during Prohibition years. Green River, "the snappy lime drink" was developed by local brewery Schoenhofen Company. Popular radio personality Eddie Kantor was hired to write and sing a jingle launching the product. Green River was produced through the 1960s.

BEST BEER, 1883. This photograph shows a typical "tied house" owned by a Milwaukee Brewery. The P. H. Best Company opened this saloon on Lake and Keeler Avenue. Lured by Chicago's great thirst for lager beer, the P. H. Best Company led an out-of-town invasion targeting in-town rivals. They were so successful that their Chicago sales force was as large as their home base of Milwaukee. (Chicago Public Library, Special Collections and Preservation Division, WGP 1.259.)

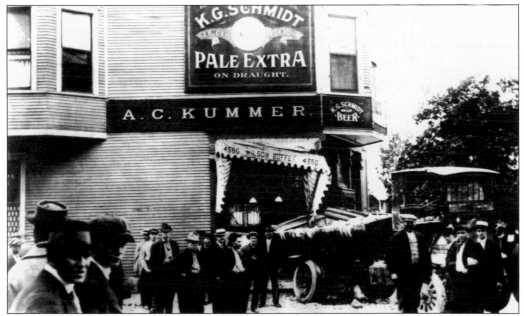

A. C. KUMMER, c. 1917. Located on the corner of Wilson and Lincoln Avenues, this local German American saloon highlighted K. G. Schmidt Beer on draught. The proprietors remained a fixture in the Ravenswood community even during Prohibition, when they served soft drinks. The building has always remained a bar and restaurant, housing Treffpunkt, Hogen's Restaurant and Lounge, and presently Daily's. (Chicago Public Library, Sulzer Regional Library, Historical Room, RLVCC 2.15.)

WEIBLINGER SALOON, c. 1900. By the dawn of the 20th century, Germans made up over one-third of the saloon keepers and bartenders in Chicago. The establishments ranged from simple, sparse rooms with basic essentials leased from a brewery, to the more refined establishments featuring gleaming woodwork and brass fixtures such as Weiblinger Saloon, located at Byron and Ashland Avenue in Lakeview. (Chicago Public Library, Sulzer Regional Library, Historical Room, WNN 1.17.)

WEIBLINGER SALOON, c. 1890. German establishments tended to be different from Irish bars, which were usually masculine, men-only places. In better German saloons, tables and chairs were provided in a separate room, especially a beer garden, where a man was welcome to bring his wife and children. Of course, an unaccompanied female was regarded as a "tart, plying her trade," and decent girls were encouraged to avert their eyes as they passed. (Chicago Public Library, Sulzer Regional Library, Historical Room, WNN 1.16.)

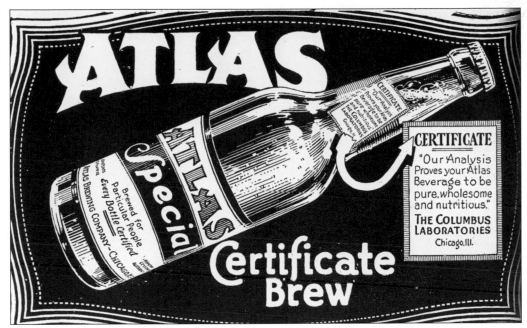

ATLAS SPECIAL, 1920s. As part of the concentration in the brewing industry, Atlas Brewery became allied with Schoenhofen Brewery. To evade prohibition laws, many nonalcoholic beers later had alcohol pumped into them. These so called "needle beers" were sometimes of questionable quality and safety, even though the certificate assures the customer of a quality product.

PABST-ETT. Many brewers branched into food production during Prohibition. Pabst Company developed what it claimed was the first cheese spread food, called Pabst-Ett. It was sold to a division of Kraft, a Chicago company started by a Canadian of German heritage, and Kraft kept the Pabst-Ett line through World War II. Pabst-Ett was the sponsor of the popular *Great Gildersleeves* radio show in the 1940s.

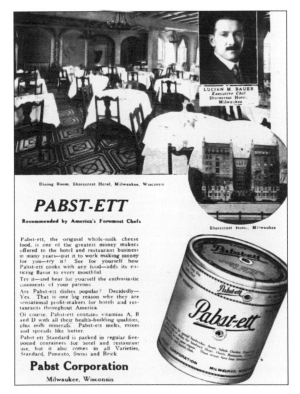

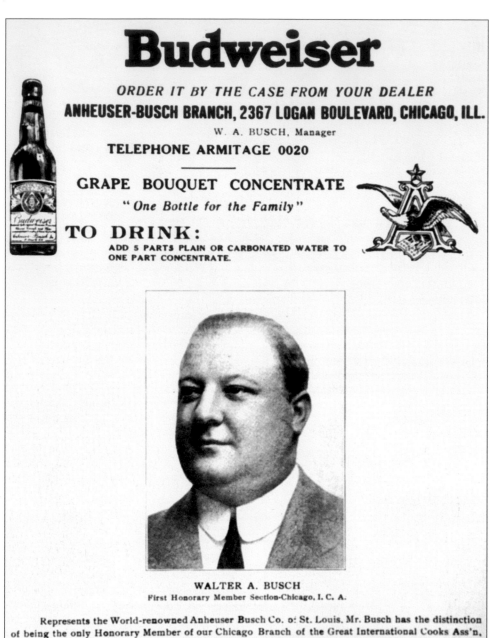

Budweiser

ORDER IT BY THE CASE FROM YOUR DEALER

ANHEUSER-BUSCH BRANCH, 2367 LOGAN BOULEVARD, CHICAGO, ILL.

W. A. BUSCH, Manager

TELEPHONE ARMITAGE 0020

GRAPE BOUQUET CONCENTRATE

"One Bottle for the Family"

TO DRINK:

ADD 5 PARTS PLAIN OR CARBONATED WATER TO
ONE PART CONCENTRATE.

WALTER A. BUSCH
First Honorary Member Section-Chicago, I. C. A.

Represents the World-renowned Anheuser Busch Co. of St. Louis. Mr. Busch has the distinction of being the only Honorary Member of our Chicago Branch of the Great International Cooks Ass'n.

The Association is very proud to have a man of Mr. Busch's caliber as a member, he has proven to be a real friend and patron of the culinarians. He is an Epicurean who appreciates and understands the most fundamental of all arts—*The Culinary Art.*

Therefore let us give a toast and raise our glasses filled with refreshing, foaming nectar—"Budweiser Beer".

Vivat Crescat Floreat

ANHEUSER-BUSCH ADVERTISEMENT, 1920s. A local branch of Anheuser-Busch, at 2367 Logan Boulevard, sold Grape Bouquet Concentrate during Prohibition to local Chicagoans, the Budweiser promotion "order it by the case from your dealer" and "one bottle for the family." Mixing the concentrate with either plain or carbonated water, the grape drink sought a new, nonalcoholic market.

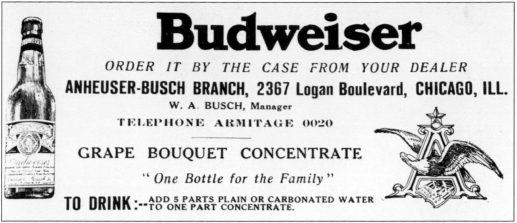

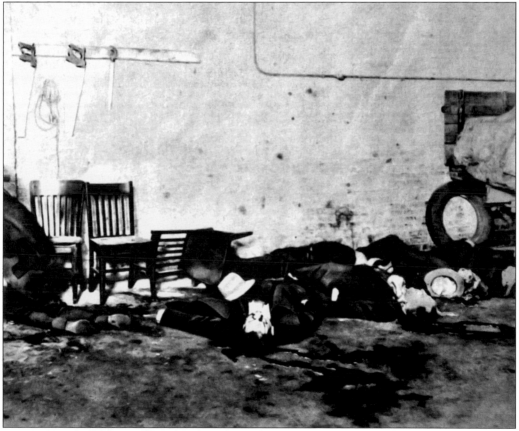

BUDWEISER'S GRAPE JUICE, 1920S. Budweiser's Grape Bouquet Concentrate beverage was not the only thing keeping Anheuser-Busch going during Prohibition. August Busch made a deal in Miami with Al Capone to supply him with 200,000 barrel tapping devices along with malt extract, a necessary ingredient to make beer.

ST. VALENTINE'S DAY, 1929. As one might expect, the leading criminal gang on the North Side was heavily German, although its leaders were Irish and Polish. As part of his consolidation of power, Al Capone eliminated the core of the North Side gang in the infamous St. Valentine's Day Massacre. The victims are shown here at the garage on North Clark Street.

THE VICTIMS, 1929. The heavy muscle in the gang was provided by its German members. The massacre victims include the two Gusenberg brothers, who were the primary assassins in the gang. Adam Heyer, bookkeeper and ex-convict, German-born Albert Kachellek, and Reinholt Schwimmer were also victims.

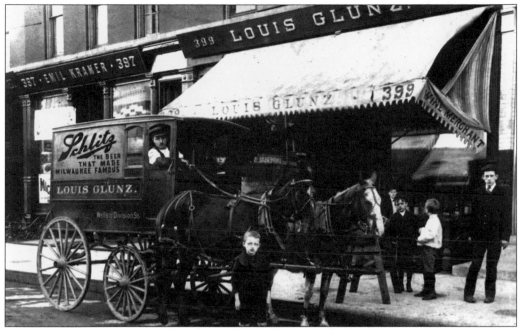

LOUIS GLUNZ. The Schlitz Company of Milwaukee gained an emotional hold on Chicago beer drinkers when after the Great Chicago Fire, Schlitz rushed emergency supplies of fresh water and beer to the city. The size of the Chicago market led out-of-town brewers Schlitz and Busch to develop export-based business models that enabled them to become national firms. The wagon delivering Schlitz is owned by the Louis Glunz Company, which is Chicago's oldest beer distributor. The Glunz family still has this wagon. The image above is from 1890, with a present-day 2009 photograph of the storefront. (Glunz family collection.)

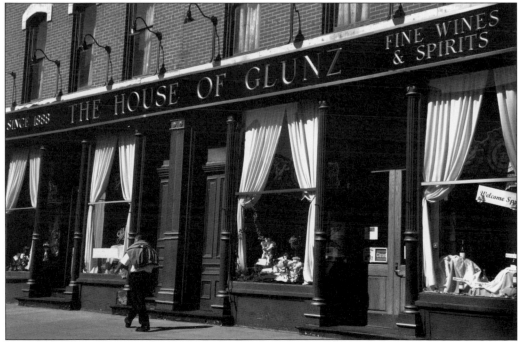

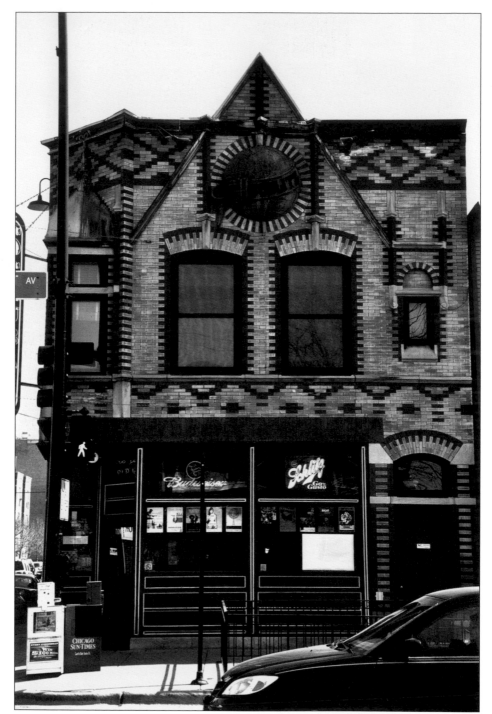

SCHLITZ TIED HOUSE, SOUTHPORT AND BELMONT. Seventy years before the Beatles, the original British invasion found English syndicates buying up Chicago breweries, including the venerable Schoenhofen Brewery. In response to this, Schlitz started using the English practice of the "tied house," where the brewery owns the public house. This original Schlitz tied house is located at Belmont and Southport Avenues. It still functions as a bar today.

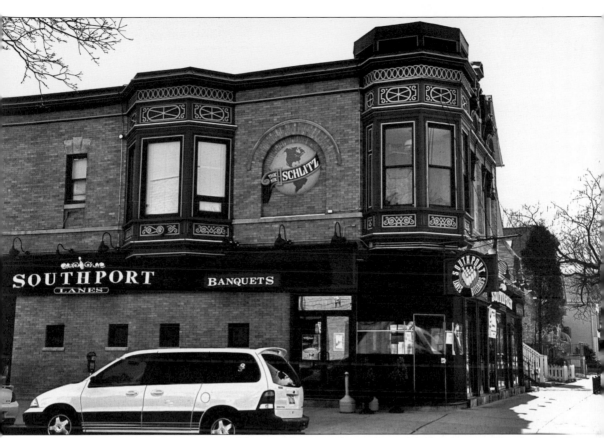

SCHLITZ TIED HOUSE. Another Schlitz tied house is located just blocks away on Southport Avenue. The Schlitz Company designed most of the tied houses to look similar, with intricate brickwork, rounded windows, and embedded Schlitz world globe logo on the side or front of the saloon. This original Schlitz tied house operates as a bar along with being a bowling alley that still hand-sets its bowling pins.

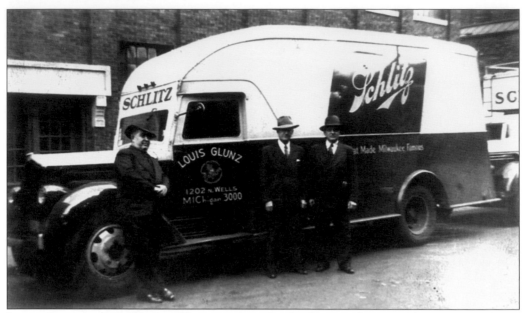

LOUIS GLUNZ, 1202 NORTH WELLS, 1940S. In the 50 years between these pictures being taken, Schlitz went from one of many to becoming Chicago's favorite beer. The Uihleins, owners of Schlitz, cemented their Chicago ties through marriage to the Siepp brewing family. They would continue to battle Budweiser for dominance while Schoenhofen and the other Chicago breweries slipped from view and into history. (Glunz family collection.)

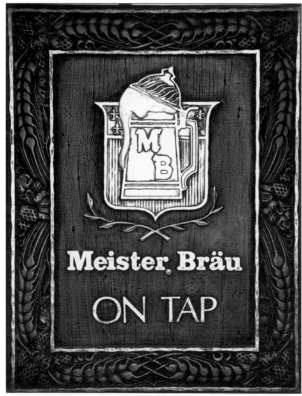

MEISTER BRAU. Meister Brau, brewed by Peter Hand, was the first Chicago brewer to put a freshness date on its beer in World War II and was the last remaining Chicago-based brewery when it closed in 1978. Miller Brewing purchased the recipe for Meister Brau Lite and marketed it as Miller Lite, which helped propel Miller to the number two spot in domestic sales.

Four

BUSINESSES LARGE
AND SMALL

Many of the German immigrants who arrived in Chicago during the 19th century were members of traditional guilds who were being displaced by large manufacturing concerns that were coming to dominate the German economy. The Chicago immigrants who arrived here possessed two skills that gave them an advantage over other immigrant groups, they were literate and they knew a craft. One study showed that by 1900, 57 percent of the German working population was classified as skilled craftsmen. These skills enabled them to become the most economically successful immigrant group. A large part of that economic success came from the businesses they founded. Some like Schwinn became iconic national companies. The majority were small and midsize companies that got their start providing specialized products to the German community.

The predominately German Lakeview neighborhood was home to many small businesses and shops. Daily commerce was a re-creation of the life they left behind in their villages. Shopping was on a personal level with the owner of the store who, more likely than not, lived above the shop. With Chicago well on its way to becoming the biggest manufacturing city in the country, it was likely that the goods purchased were also made within a few miles of the store. In many fields, the German element dominated, such as the manufacturing of musical instruments. One of the largest clothing manufacturers, Hart, Schafner and Marx, founded in 1872 by Harry Hart, from Rhenish Hesse, employed 5,000 people at its peak. It announced its closing in 2009.

The food industry was an area that Germans were particularly attracted to. Fifty percent of Chicago's bakers were German. The neighborhood German bakery would be almost as common as the neighborhood saloon. But as in Germany, these local establishments would soon be under pressure from large firms.

The downtown hotels provided a great deal of employment for the German community. Some hotels, such as the Eitel Brothers, Bismarck, were German owned. Almost all the kitchens in the large hotels were run by members of the International Cooks Association, a trade organization whose local chapter was founded by German cooks. Until supplemented by unions, this organization was a conduit for finding German employment in the culinary trades. These and other skilled occupations provided the economic engine that drove the German community's prosperity. This affluence encouraged exodus to the nearby suburbs.

C. F. GUNTHER. C. F. Gunther, a German immigrant known as "Chicago's Candy Man," is credited with the invention of caramel candy. Gunther is something of an anomaly among Germans. He was a confederate supporter and only came to Chicago after his arrest by Union forces. His collection of Civil War artifacts, including the table that Robert E. Lee signed the surrender on, formed the core of the Chicago Historical Society's Civil War collection. (Chicago Public Library, Sulzer Regional Library, Historical Room.)

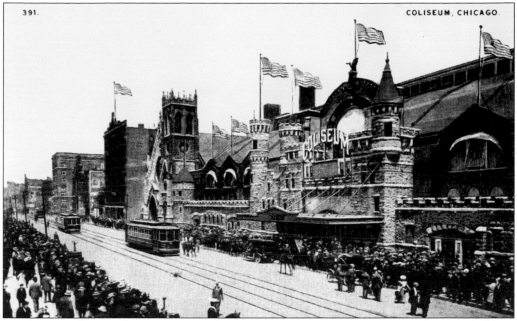

THE COLISEUM. The Coliseum started life as Libby Confederate Prison, located in Virginia. It housed Union prisoners during the Civil War. It was dismantled and brought north by candy magnate and inveterate collector C. F. Gunther and became a Civil War museum. After several additions and alterations, it became a large hall and hosted the Republican convention of 1907.

GUNTHER'S CANDY STORE. C. F. Gunther opened his candy store on South State Street after the original building burned in the Great Chicago Fire. Besides manufacturing and selling candy here, he also displayed some of his vast holdings of historical curiosities. He was not a discriminating collector. If it was old and a first, he bought it. Included in his collection was a first issue of Auld Lang Syne.

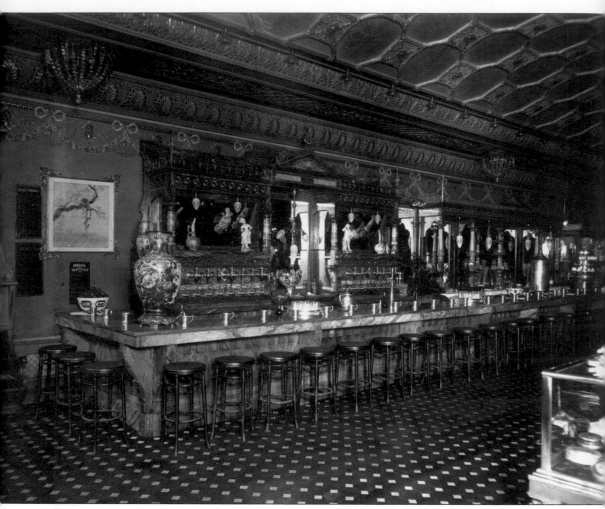

INTERIOR VIEW, 1890s. This is an interior view of Gunther's Candy Store. Featuring sumptuous fittings and a marble counter, it was a major tourist attraction. C. F. Gunther used the profits from this store to amass a large, varied collection of all things historical. (Chicago History Museum, ICHi-59961.)

EARLY STUDIO PORTRAITS, 1870S. Staying connected to relatives in Germany and those who had immigrated to other large cities in the United States meant having the family photographed. Early German and German American photography studios of Herman Neidhardt, 238 North Milwaukee, 1877; and August Kruse, 292 North Avenue, 1874 were just two of the noted early photographers of the city.

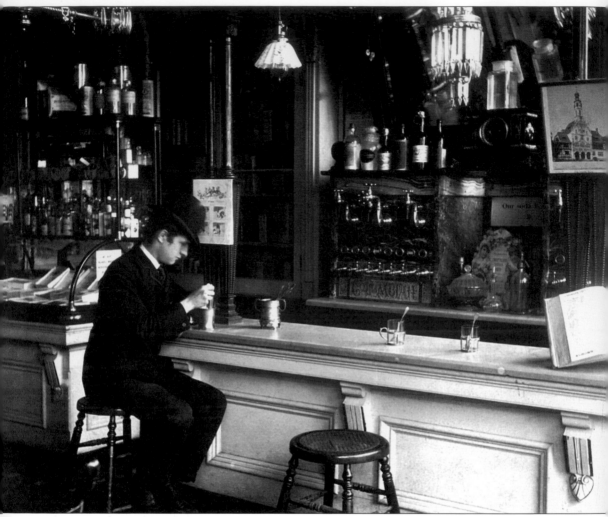

VOGELSANG DRUG STORE. Located on the northwest corner of Lincoln and Fullerton Avenues, Vogelsang's Drug Store is known to have been one of the first soda fountains on the North Side of Chicago. Across the street from the McCormick Seminary, and down the street from various German Verein meetinghouses, Vogelsang's Drug Store serviced the growing German community of this Lincoln Park neighborhood. This photograph dated 1895 shows an interior view of the store. (Chicago Public Library, Sulzer Regional Library, Historical Room, RLVCC 1.53.)

KRAUSPE FURNITURE STORE, c. 1890.
Mr. and Mrs. Christian Krauspe
established one of the first businesses
and structures on Belmont Avenue in
1887. Being a furniture maker, German
immigrant Christian Krauspe began
making coffin pedestals along with
small furniture pieces. With changing
times and funeral practices, Krauspe
became educated in the practice of
embalming and opened a small funeral
parlor, thus taking the funeral out
of the home and into a full-service
undertaking establishment. (Chicago
Public Library, Sulzer Regional Library,
Historical Room, RLVCC 1.29.)

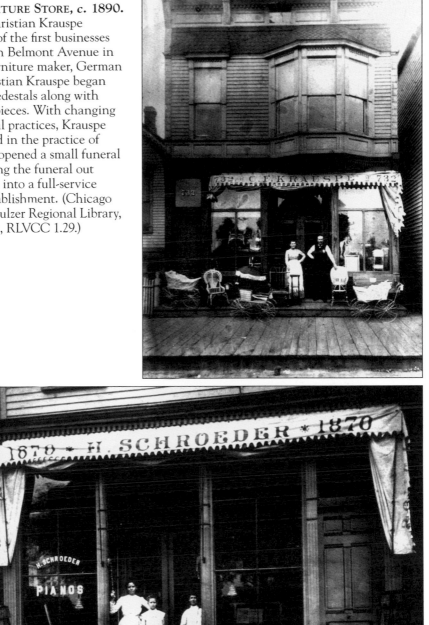

SCHROEDER PIANOS, c. 1900. Herman Schroeder came to the United States from Germany
and set up shop at 1870 North Ashland Avenue in 1888. His original pianos were made by
hand. The business has seen three generations conducting business, supplying pianos for WGN
radio station and Riverview Amusement Park. (Chicago Public Library, Sulzer Regional Library,
Historical Room, SBC 1.49.)

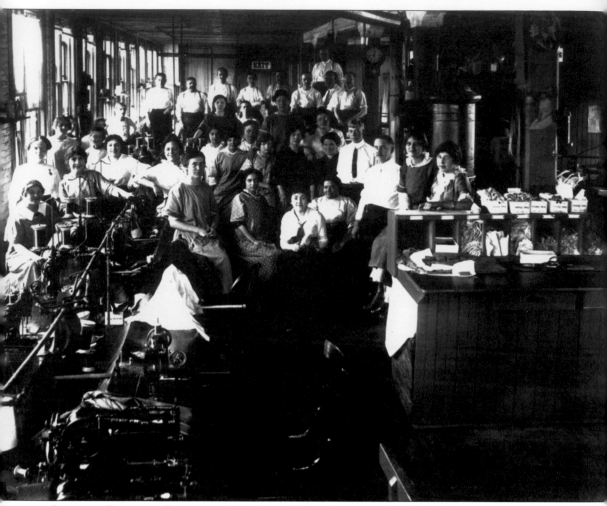

CHICAGO GARMENT FACTORY, 1910. Born 1881 in Germany, Elisabeth Christman immigrated with her parents to Chicago in 1884. Working 10 hours a day, 6 days a week at the Eisendrath Glove Company at age 13, Christman joined coworker Agnes Nestor in a labor strike that insisted that the Eisendrath Glove Company pay for needles, oil, and power to their machines. Elisabeth dedicated her life to improving the working conditions of women through labor reform.

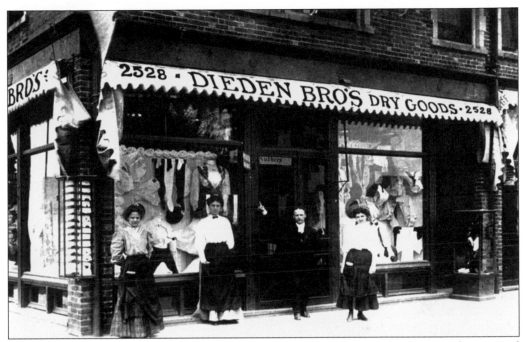

DIEDEN BROTHERS DRY GOODS STORE, 1906. Brothers Albert and Henry Dieden opened the North Side Dieden Brothers Dry Goods Store in 1906. Active in both business and civic organizations, Albert was a two-term president of the Lincoln Square Commercial Association, while Henry held the position of president of the Retail Dry Goods Merchants of Chicago for eight years. Building their dry goods store led them to expand to many locations, finally settling into 4810–4812 North Western Avenue. (Chicago Public Library, Sulzer Regional Library, Historical Room, RLVCC 1.21)

LOUIS RUCKHEIM. One person who put C. F. Gunther's caramel invention to good use was Franco-Prussian war veteran Louis Ruckheim. He, along with his brother, put caramel on popcorn and invented Cracker Jack, although their original recipe called for molasses. Like several other Chicago food products, Cracker Jack gained national exposure at the World's Columbian Exposition of 1893.

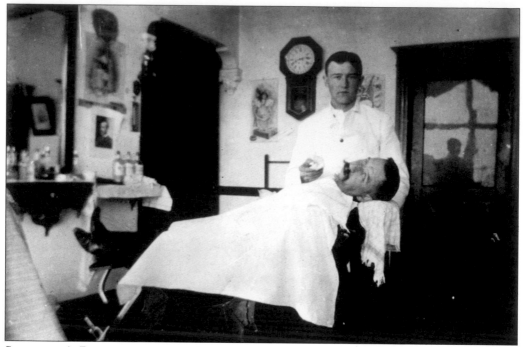

SCHNIEDER'S BARBERSHOP, 1898. S. E. Gross, the owner of the largest real estate company in Chicago, developed Humboldt Park. He targeted German immigrants, using German-language pamphlets offering the chance to own one's own home. The Schnieder Barbershop was one of the many small German businesses that opened in Humboldt Park to serve that market. (Chicago Public Library, Special Collections and Preservation Division HUM 1.3.)

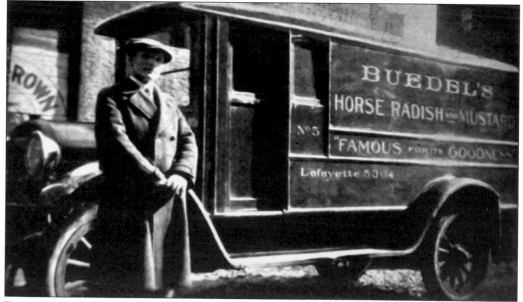

BUEDEL FOODS, 1920s. Buedel's motto, "Famous For Its Goodness," appeared on delivery trucks and advertisements in the city of Chicago. Known for its horseradish and mustards, this early family-run business was located at 3814 South Kedzie Avenue and then at 3543 South Hoyne Avenue.

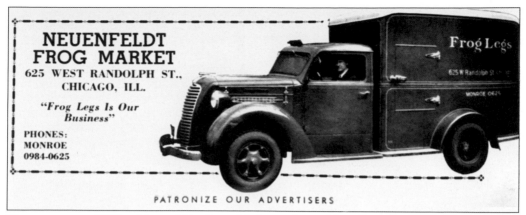

NEUENFELDT, 1920s. Neuenfeldt Frog Market, where "Frog Legs Is Our Business," was located at 625 West Randolph Street, and before this location, at 225 North Clark Street. The business supplied larger hotels and upscale restaurants of the city with fresh frog legs. The company was also a dealer and distributor of turtles and frogs as listed in a 1917 publication of *Experimental Pharmacology.*

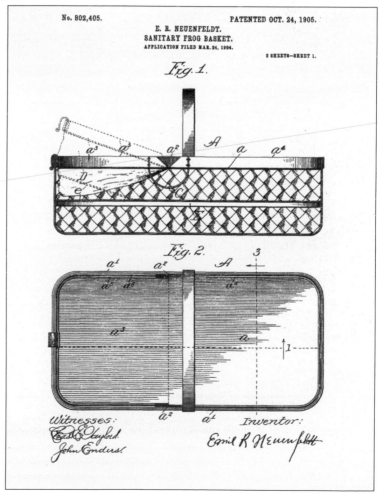

No. 802,405.

PATENTED OCT. 24, 1905.

E. R. NEUENFELDT.
SANITARY FROG BASKET.
APPLICATION FILED MAR. 24, 1904.

2 SHEETS—SHEET 1.

Fig. 1.

Fig. 2.

Witnesses:

Inventor:

Emil R. Neuenfeldt

EMIL NEUENFELDT. This application for a Sanitary Frog Basket was filed with the U.S. patent office on March 24, 1904. The invention was a safe and sanitary way of collecting and storing frogs. The patent was granted on October 24, 1905.

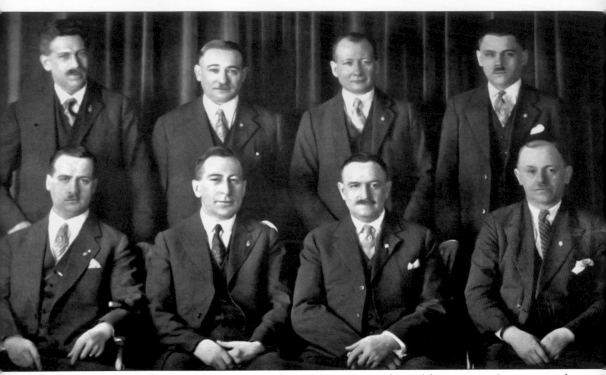

INTERNATIONAL COOKS ASSOCIATION, 1920s. These are members of the executive International Cooks Association Board of Officers. From left to right are (first row) Henry Burkhart, chef of the Covenant Club; Alfred Fries, chef at the Pompeian Grill of the Congress Hotel; Otto Johannisson, chef of Hotel Atlantic; and Jack Geyer, assistant chef at the Grill Rooms of the Congress Hotel; (second row) Walter Luethke, chef; J. Biggs; Joseph Willi, caterer; Robert Machts of Mauer and Machts; and Carl Werthmann, pastry chef at Maillard.

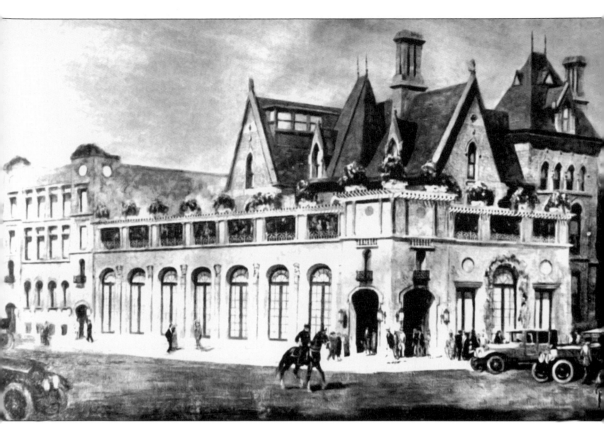

PROPOSED INSTITUTE, 1920S. This oil painting by noted artist Otto Hake depicts a proposed exterior view of the American Culinary Training Institute due to be erected on Ontario, between Rush and Cass Streets in 1920. The institute would claim its mission as graduating "men who will become the famous chefs of tomorrow, women who will become the leading domestic science exponents of the world."

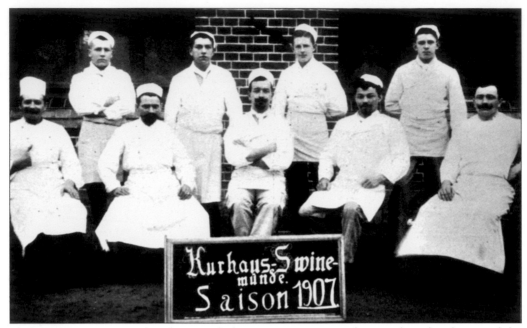

HENRY MAUER, 1907. This photograph shows Henry Mauer at the age of 18 when he joined the ranks of the International Cooks Association in Europe. Immigrating to the United States, Henry Mauer opened Mauer and Machts, Culinary Reference Bureau at 538 South Dearborn Street. Filling positions for major hotel and restaurant kitchens since 1894, the company's motto boasted "a complete culinary employment service backed by thirty years of practical experience."

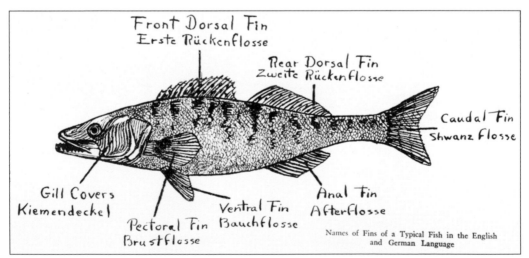

GERMAN FISH ILLUSTRATION, 1920s. Bilingual German American food preparation illustrations could be found in many culinary books and pamphlets used in Chicago. This particular illustration, dating from the 1920s, shows both German and English language usage for common fish anatomy. With a large number of predominately German-speaking chefs and cooks, definition of common terms in both languages became paramount to efficiency within the kitchens.

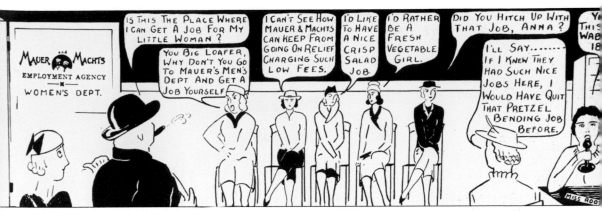

MAUER AND MACHTS. This advertisement from the 1920s depicts a new worker to Chicago commercial kitchens—women. Women were not allowed or were subjected to lower, nonprestigious tasks within hotel and restaurant kitchens, and this cartoon reflects a growing sense of liberation and changing roles for women of the time. Mauer and Machts, a local employment agency strictly filling jobs within the food industry, saw the growing opportunities of a female work force. By establishing a separate women's division in its employment agency, the company began placing women within the predominately male-dominated field.

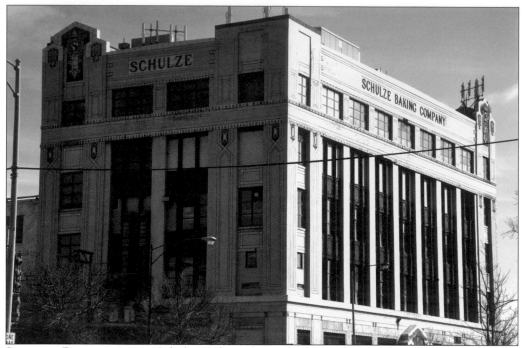

SCHULZE BAKERY, 2009. Schulze Bakery, located on Garfield Boulevard, was established by Hartz Mountain German immigrant Paul Schulze in 1893. The Schulze Bakery became the largest wholesale bakery in the city. Chicago was the headquarters for the International Bakers Union.

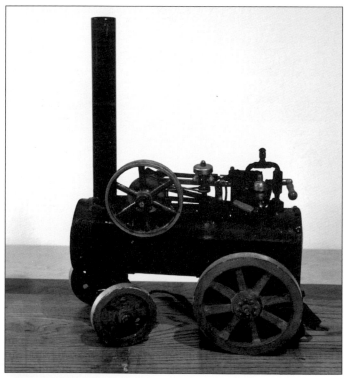

HANDMADE TOY STEAM TRACTOR. Early-20th-century toys were miniature representations of the real thing. Chicago became a leading center for toy production. Structo Toys, founded by two German immigrants, was noted for its stamped metal toys, especially Erector Sets. Toys like this handmade steam tractor were made by numerous North Side German craftsmen and sold in small shop fronts, and in some cases, door-to-door.

EXCELSIOR MOTORCYCLES. This motorcycle company was a division of the Schwinn Bicycle Company, started by German immigrant Ignatz Schwinn in 1895 during the middle of the bicycle boom in the United States. Schwinn became interested in motorcycles and bought Excelsior in 1913. In 1917, he purchased the Henderson Motorcycle Company, which he moved to Chicago from Detroit. During the 1920s, Henderson-Excelsior was the third-largest motorcycle manufacturer in the United States after Harley Davidson and Indian. The profit from the motorcycle division helped Schwinn survive the lean profit margins of the 1920s. Excelsior-Henderson ceased production in 1931. Schwinn Company severed its last Chicago tie when an investment group backed by Sam Zell purchased the company and moved it to Boulder, Colorado, in 1993.

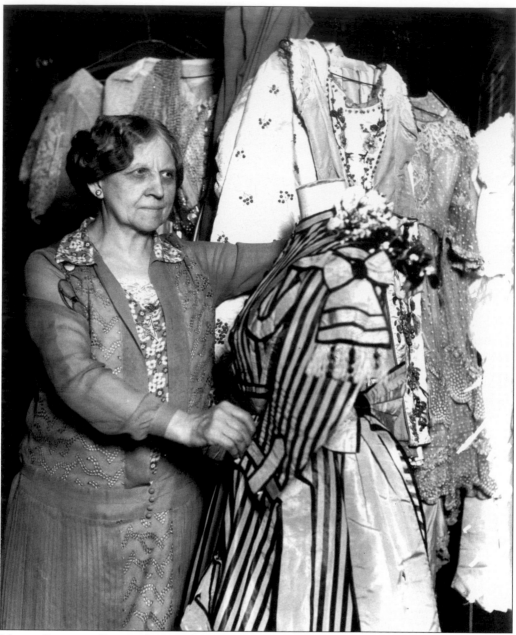

MINNA SCHMIDT STORE. German-born Minna Moscheroscht Schmidt was known as Chicago's "Fairy Godmother." She started her costume business designing outfits and wigs for children's plays at her dance studio. This would lead her to open what would become Chicago's largest costume leasing and sale businesses. In an age where costume balls were in vogue with upper-class society, her store and factory at 920 North Clark would rent over 60,000 costumes a year. (Chicago History Museum, ICHi-59959.)

Minna Schmidt. An early feminist, Minna Schmidt exhibited over 400 dolls representing significant women throughout history at the 1933 world's fair, the Century of Progress International Exposition in Chicago. Becoming a leading expert on dress and costume design, she later taught one of the first university-level courses on the history and creation of costume. Extremely philanthropic, she gifted her Evanston mansion to Northwestern University.

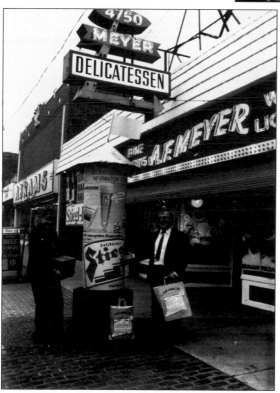

A. F. Meyer Delicatessen, 1988. The pride of Lincoln Square, this delicatessen featured German food products and imported beer and wines along with some of the finest sausages. The delicatessen provided German-speaking counter staff encouraging bilingual conversations while ordering. The noted red and white checkered handled bags were a tradition upon checkout.

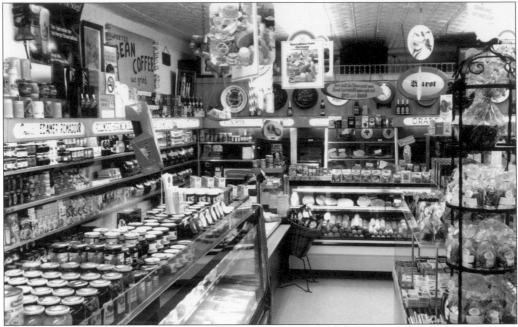

INTERIOR OF MEYERS DELICATESSEN, 1998. Neat, tidy, and well stocked with anything one could imagine from Germany, A. F. Meyers Delicatessen's unique storefront serviced the Lincoln Square and surrounding German communities with homemade items and hard-to-find imported Austrian and German goods. Known for its Easter and Christmas candies, the midsection was devoted to children, displaying unique marzipan pigs and imported German chocolate Santas and bunnies. Meyers closed in 2006.

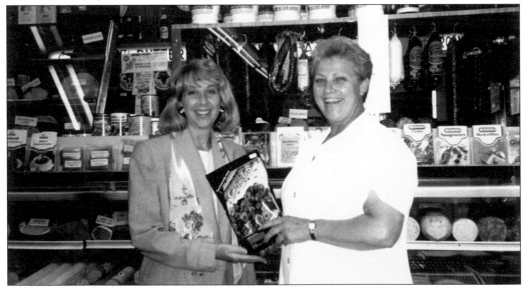

THE MEYERS LADIES. Greeted with precision and a smile, fast-paced Meyer's Delicatessen staffed the counter with multigenerational help, well versed in numerous languages, especially German. Meyers operated in the old world style, numbered tickets assigned one's position in line, all items were wrapped in white butcher paper, price noted in pencil on the deli goods and wrung up at one of two stations in the busy, elbow-to-elbow delicatessen.

Five

LEISURE AND
RECREATION

No other ethnic group displayed a more unabashed nostalgia in their restaurants and recreation than the Germans. Bier Stube's and meeting halls around Chicago were heavily festooned with the mugs and trappings that harkened back to a supposed, simpler folk time. As German brewers introduced and changed American tastes toward their lighter, lager-style beer, so German entrepreneurs gave them places to enjoy it. They opened large, often-elaborate beer gardens that were a staple of Chicago life into the 1950s. Like so much of Chicago's history, the World's Columbian Exposition of 1893 advanced this trend. Wide public exposure to the café atmosphere at the German and Austrian villages popularized the German love of outdoor dining and drinking. With the close of the World's Columbian Exposition, this trend continued with investors establishing San Soucci, a fair re-creation that featured alfresco dining and live entertainment. An addition of rudimentary rides proved so popular that Sans Soucci and North Side Riverview, formally known as Shooters Park, quickly evolved into amusement parks. This created a generational rift within the singing societies and clubs who held regular meetings there. Older members tended to dislike the changed atmosphere environment that the rides brought, while young members flocked to them.

While the larger beer gardens gave way to higher population densities and real estate prices, the small café attached to the local restaurant remained a staple in German neighborhoods until the advent of air-conditioning made sitting in the summer heat less attractive.

Whether they had a beer garden or not, the German saloon or restaurant was ubiquitous with one in almost every neighborhood regardless of its ethnicity. German cuisine was Chicago's first introduction to a non-Anglo ethnic fare. Often this was served in an establishment that was owned or leased by a brewery. Larger, fine-dining restaurants often featured the regional fare of their owners. Diners had the option of frequenting places that featured Bohemian, Austrian, or Bavarian-style meals. One such restaurant, Schlogl's, known as "Chicago's Algonquin Club," was frequented by well-known writers Carl Sandberg, Theodore Dreiser, Sherwood Anderson, Ben Hecht, and others during the 1920s. Others were noted for their magic or musical entertainment. The following bars and restaurants were some of the most popular and long lasting. They anchored Chicago's entertainment scene and played host to numerous local and national celebrities. Eventually they all went dark as times and tastes changed.

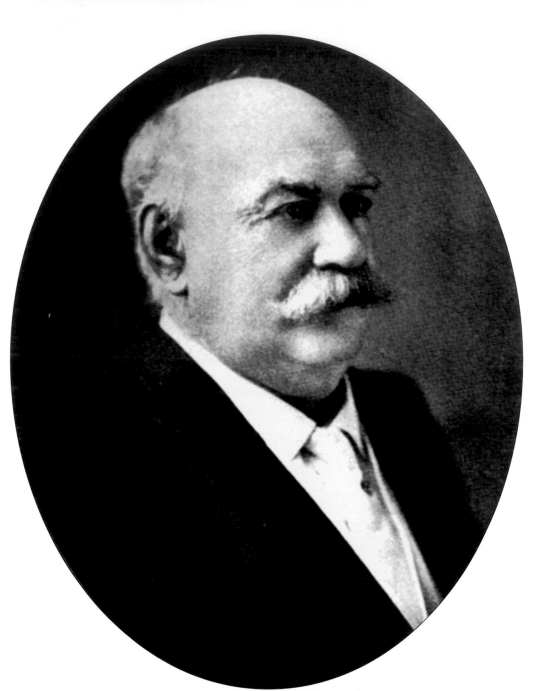

RIVERVIEW. Wilhelm Schmidt and his partner purchased a 22-acre site at Belmont and Western Avenues in 1903 from a German shooting club, Der Nord Chicago Schutzverein, or the North Chicago shooting club. There, they opened a beer garden featuring German bands. The Casino Restaurant then became the summer headquarters for the Verein Deutscher Weltkriegs Veteranen Chicago, or the German World War veterans club of Chicago.

VOGELSANG'S RESTAURANT. In 1903, Vogelsang's, along with other major downtown restaurants and hotels, suffered a two-week strike by union waiters and union cooks. Arranging for agents to seek out nonunion help outside the local union jurisdiction, the restaurant opened again with a smaller waitstaff of nonunion help. Prior to the strike, waiters were making an average of $25 in tips along with their salary.

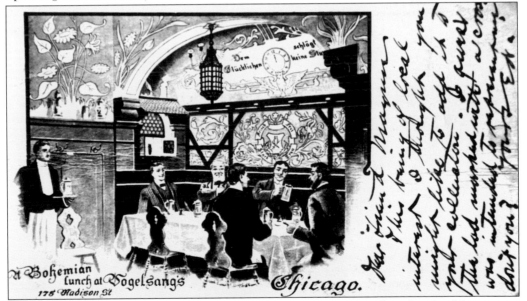

VOGELSANG'S RESTAURANT AND BUFFET. Having worked in various large hotels of Cincinnati, German American Ohio-born John Zachariah Vogelsang brought his knowledge of the hospitality and service industries to Chicago. Opening his own establishment in 1883, at 178 Madison Street, Vogelsang's Restaurant and Buffet served traditional "Bohemian lunches" to an increasing German populace within the city.

PHILIP HENRICI. Philip Henrici's first restaurant was a simple lunch counter that stood on the corner of the Marshall Field, or present-day Macy's block, in 1868. Known for his baking skills and acknowledging his Austrian upbringing, Henrici opened his new restaurant at 67–71 West Randolph Street in 1893 during the city's hosting of the World's Columbian Exposition. A man of definite opinions, Henrici resigned in protest from the Germania Club over the cancellation of the installation of Gov. John Peter Altgeld's portrait.

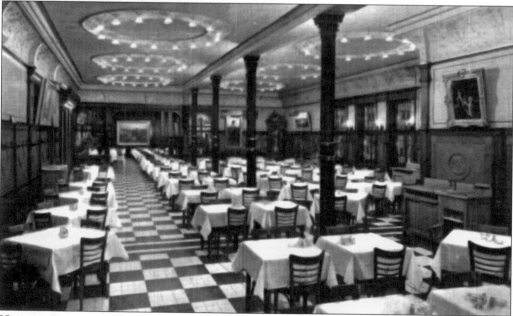

HENRICI RESTAURANT POSTCARD. Noted for its fine dining, this restaurant rivaled New York's Sardi's Restaurant and Los Angeles's Brown Derby. In 1914, 6 to 10 members of the waitress union picketed outside the famous restaurant, demanding $8 for 6 days of work. The appellate court heard the Philip Henrici Company versus Alexander lawsuit on February 5, 1914, in one the first female restaurant union actions.

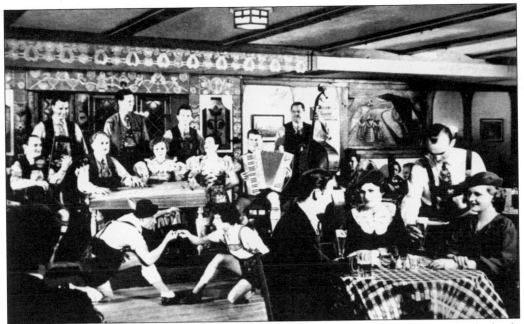

BISMARCK HOTEL POSTCARD. Established in 1894, the Bismarck Hotel was known for the lively Bier Stube, an inviting, traditional bar and restaurant, which served homespun German food. Providing Bavarian entertainment nightly, the Bier Stube became a popular destination for out-of-town guests.

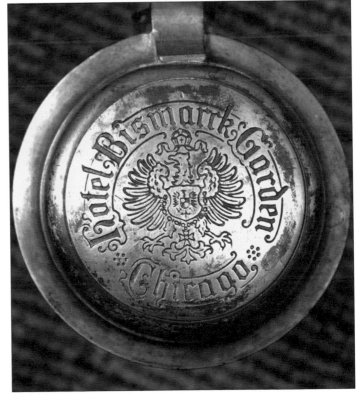

BISMARCK PEWTER STEIN. Many local restaurants and hotels offered their customers beer in clear glass steins. Some sold these as souvenirs to guests. This particular stein shows a slight variation using an etched pewter lid instead of the more common ceramic, painted logo lid.

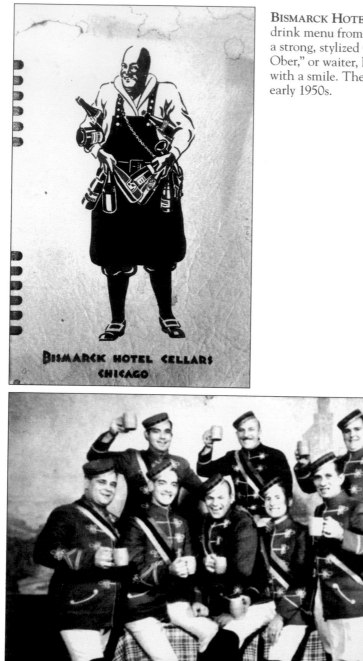

BISMARCK HOTEL CELLARS. This wine and drink menu from the Bismarck Hotel depicts a strong, stylized Germanic logo with "Der Ober," or waiter, handling multiple wine bottles with a smile. The drink menu is from the early 1950s.

OLD HEIDELBERG INN POSTCARD. The Old Heidelberg Inn first appeared as a featured restaurant in the Chicago 1933 Century of Progress International Exhibition. After the fair's closing, the restaurant assumed space in the old Randolph Theater on Randolph Street at State Street. Featuring nightly performances in the dining room by an all-male group called the Octet, the Old Heidelberg Inn maintained a long run as a favorite downtown restaurant until Ronny's Steakhouse took over. Argo Tea now occupies the present-day site.

EXTERIOR VIEW OF THE RED STAR INN. This original art of the Red Star Inn rendered by Chicago artist Harlan C. Scheffler once hung in the historic restaurant. The line art depicts exact architectural features of the once-historic building that was located across the street from the Germania Club.

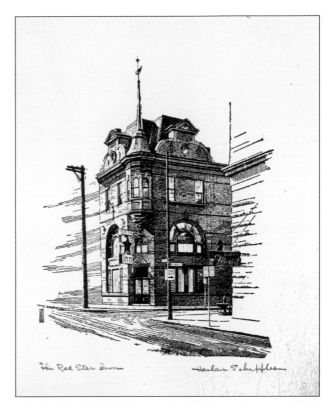

RED STAR INN. Opened by German immigrant Carl Gallauer in 1899, the Red Star Inn, located at 1528 North Clark, became one of the best-loved German restaurants for seven decades until giving way to urban renewal. The Riggio family purchased the restaurant, relocating it to Old Irving. The Red Star Inn closed in 1983. Tony Riggio is holding one of many artifacts from the Red Star that are found in his restaurant, Riggio's, of Niles.

INTERNATIONAL LEISURE TRAVEL, 1900s. Rising affluence enabled many second-generation Germans to visit their parents' homeland. These two young women pose before their journey. The Hamburg line was the preferred steamship line to make the passage.

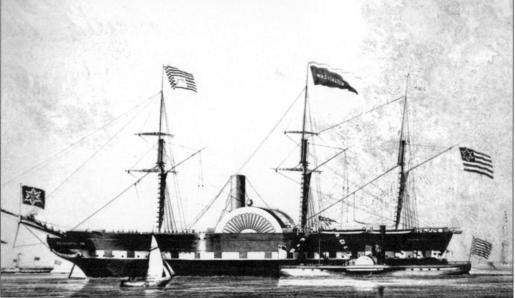

DAMPFER WASHINGTON. This early ship of the Norddeutscher Lloyd line traveled from Bremen to New York where most early emigrants landed, then to travel cross-country to Midwest cities such as Chicago. This ship carried passengers in the early 1860s.

Bremen. With changing technologies, the Norddeutscher Lloyd lines offered more comfort to passengers making the voyage to the United States. The *Bremen* was in service around the dawn of the 20th century, with its main route traveling from Bremen to New York City. Offering more luxuries and class accommodations, this ship became one of the favored traveling modes.

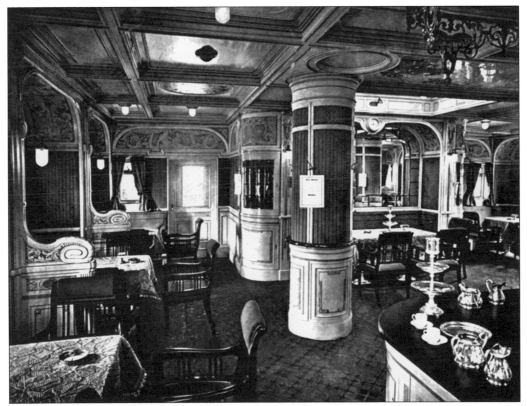

INTERIOR BREMEN, 1904. An interior view of this tea and sitting room shows the increased luxuries offered on the sea. No longer just a mode of transportation, traveling internationally by ship allowed the passenger the comforts of home while at sea. A tiered structure of accommodations based on price levels offered immigrant, vacationer, and business passengers a variety of services and rooms.

FRED BUSSE. Chicago's Germans have held almost every civil elected and appointed office, but Fred A. Busse was the only one to be elected mayor. He appointed a vice commission, but his tenure was ridden with graft and corruption. Busse's image was even used by brothel owners to promote business. His main accomplishment was building the Michigan Avenue Bridge and turning Pine Street into Michigan Boulevard.

"THE CHRISTMAS SCHOONER." Herman Schuenemann brought Christmas trees to Chicago from Michigan on a three-masted schooner. He started what became a Christmas tradition by selling trees directly to the public from the dock at the Clark Street Bridge. Schuenemann sold trees for 50¢ to $1. He always set some aside to be given for free to those in need. He died in November 1912, bringing trees to the city for Christmas. His saga has been memorialized in the popular Christmas play "The Christmas Schooner."

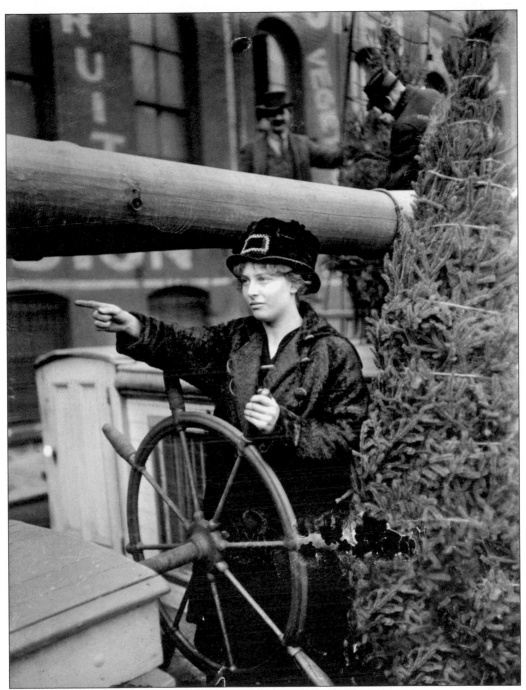

ELSIE SCHUENEMANN, 1900s. Barbara Schuenemann and her daughter continued the Christmas tree tradition following her husband's death. Barbara decided to bring the trees into the city by rail. The Chicago Yacht Club and the U.S. Coast Guard recently revived the tradition and bring a load of trees to Navy Pier for disbursement to needy families. (Chicago History Museum DN-0065543.)

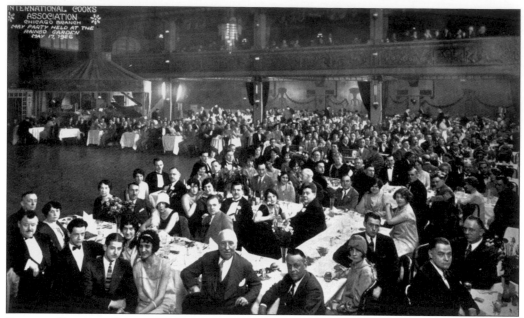

RAINBO GARDENS INTERIOR, 1920s. In 1921, German American Fred Mann purchased and renovated the new $1 million facility once known as Moulin Rouge Gardens, renaming it Mann's Million Dollar Rainbo Room. The new nightclub was named for Mann's wartime service in the U.S. Army 42nd Infantry Rainbow Division. Wanting a step up from the usual German beer garden, his nightclub featured some of the biggest names in Vaudeville, seating 2,000 patrons, with additional seating for 1,500 on the dance floor.

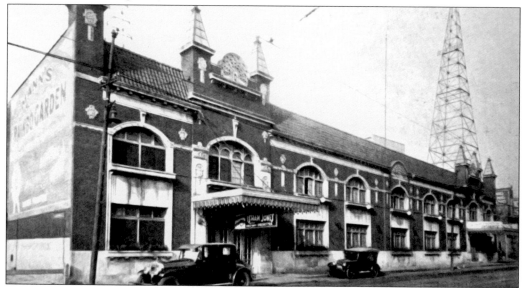

RAINBO GARDENS, 1920s. In 1927, during Prohibition, the Rainbo Gardens was renamed to Rainbo Fronton and was converted to a casino and sporting venue. Undergoing other changes in 1934, the owners responded to the international flavor of the world's fair and renamed it the French Casino. In 1957, it was changed to Rainbo Arena, where it welcomed the Blackhawks as a practice ice rink. The Rainbo, located at 4812 North Clark Avenue, was finally torn down in 2002 to make way for a new condominium development.

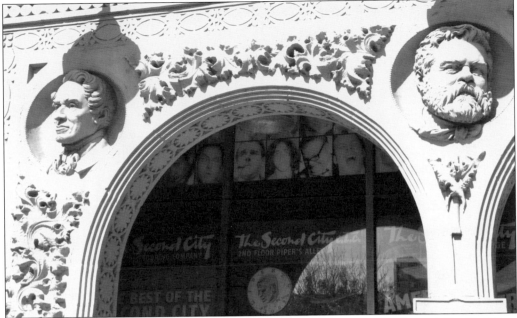

SCHILLER THEATER RELIEFS. These reliefs of German artists, now on the Second City Building, were originally part of the Schiller Theater on Randolph Street just west of State Street. The Schiller Theater building was an Adler and Sullivan design and home of the German Opera Company. Economic hardships forced the opera company to move. Mies van der Rohe, Le Corbusier, and Philip Johnson pleaded that the theater not be razed. The fight to save the Schiller, renamed the Garrick, was led by Richard Nickel and galvanized the historic preservation movement. The building was razed in 1961.

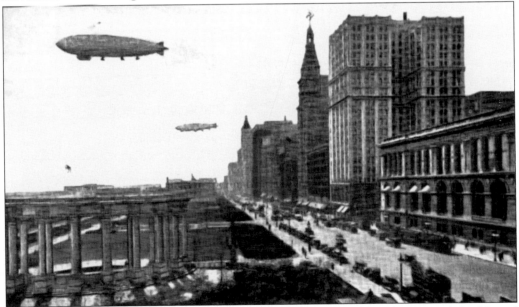

MICHIGAN AVENUE ZEPPELIN. With the invention of the dirigible, Chicago and the United States went wild for anything relating to this new mode of transportation and aeronautic capabilities. This postcard depicts Zeppelins over Michigan Avenue.

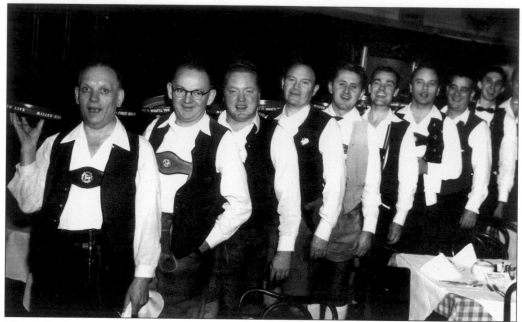

MATT IGLER. Located at Belmont Avenue, near the cross street of Ashland and Lincoln Avenues, Matt Igler's Casino and Restaurant featured dinner with entertainment. Their famed singing waiters would engage their audience in German song, encouraging participation from the audience. The restaurant closed in the early 1980s.

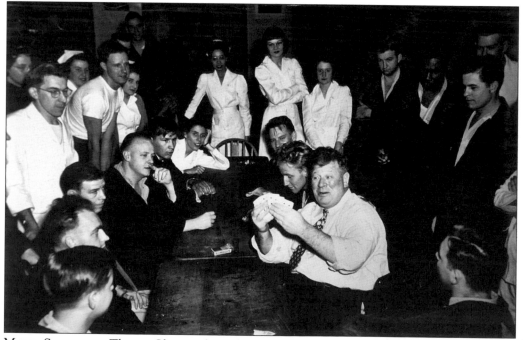

MATT SCHULIEN. This is Chicago legend Matt Schulien entertaining his customers in his restaurant. He is famous in magic circles for inventing many of the slight-of-hand card tricks that are the staple of today's magic acts. Customers came for over six decades to be amazed by Schulien and his sons. (Schulien family collection.)

No. 1800 Willow. Matt Schulien started his restaurant Schulien's at Willow and Halsted. During Prohibition, he ran it as a speakeasy and was arrested several times. He later moved the business to Irving Park Avenue. His fame as a magician drew many people, including Vice Pres. Charles Dawes and Charlie McCarthy creator ventriloquist Edgar Bergen. (Schulien family collection.)

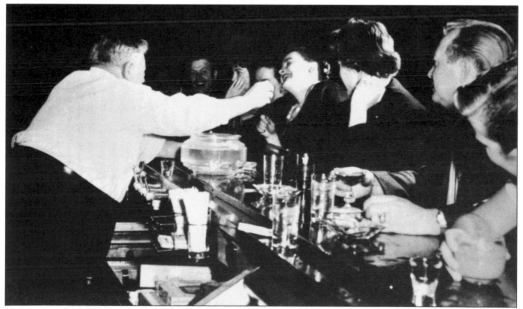

The Goldfish Trick. Matt Schulien always mixed magic with laughter. He kept a bowl of goldfish behind the bar and would encourage patrons to swallow one by doing so himself. One afternoon, a customer told Schulien that he swallowed a goldfish in his college days at Yale and it was disgusting. Schulien told him that Ivy League dummies swallowed live goldfish, Chicago bartenders swallowed carrots cut to look like goldfish. (Schulien family collection.)

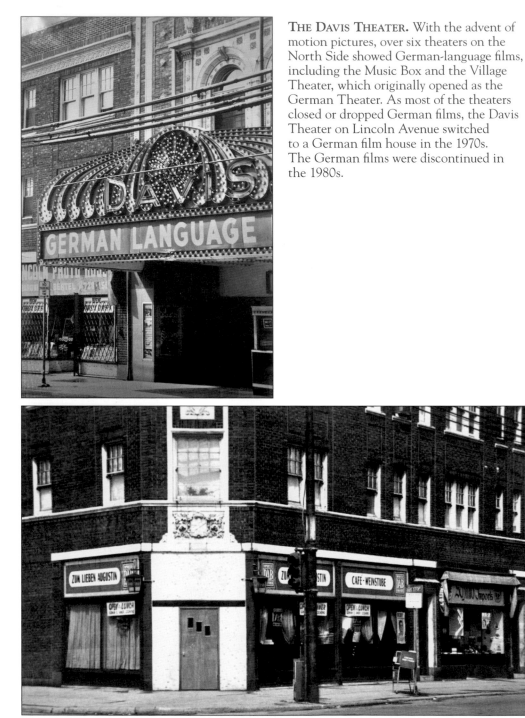

THE DAVIS THEATER. With the advent of motion pictures, over six theaters on the North Side showed German-language films, including the Music Box and the Village Theater, which originally opened as the German Theater. As most of the theaters closed or dropped German films, the Davis Theater on Lincoln Avenue switched to a German film house in the 1970s. The German films were discontinued in the 1980s.

ZUM LIEBEN AUGUSTIN. The Lincoln Square neighborhood was the last remnant of the once sprawling German North Side. Gentrification, changes in tastes, and population led to the gradual extinction of these small businesses on Lincoln Avenue and others like them that gave the neighborhood its distinct ethnic feel. Today Asian cuisine restaurants are now the most common eating establishment of the neighborhood.

Six

WAR AND REACTION

Chicago's German World War I experience mirrored that of their overseas cousins; it began with enthusiasm and parades and ended with loss, isolation, and shattered public prestige. The public image of German Americans went from admiration for their hard work, thrift, and economic success to a questioning of their loyalty and suspicions of a culturally innate bent toward ruthless militarism and authoritarianism.

Part of this was engendered by the federal government. Concerned over a perceived lack of enthusiasm for the war, the Woodrow Wilson administration hired journalist George Creel to spin popular support. Creel's propaganda helped create a self-sustaining anti-German hysteria that led to civil rights violations and indignities large and small being inflicted upon German American citizens. Anything Teutonic was ripe for renaming. Even sauerkraut was rechristened "liberty cabbage." On a more intimidating note were several instances of German Americans being shot and lynched for perceived lack of patriotism.

At the outbreak of war, many Chicago Germans couched their support of the kaiser's war effort in terms of the social Darwinism of the time that preached of genetically superior and inferior races. Maladroit actions by the German government threw Chicago's Germans on the defensive. The sinking of the *Luisitannia* coupled with the Zimmerman Telegram advocating an alliance with Mexico against the United States made support for Germany appear treasonous.

As the furor increased, the two groups most sympathetic to the German cause, the Swedes and German Jews, distanced themselves. Influential Rabbi Emil Hirsh was forced to recant his avowedly pro-German statements in response to his congregation's criticisms. For his position of neutrality, Cardinal George Mundelein was poisoned by an enraged, young German immigrant. Corporations seized on the heavily German component of unions to suggest linkage between union activity and disloyalty. Nativists, who had been fighting a 60-year seesaw battle over German instruction in Chicago schools, used the war as the fulcrum to put the issue to rest.

The German community fought these negative images through public displays of patriotism. They purchased as many liberty bonds as the next two ethnic groups combined. Voluntarily, they changed the names of many of their organizations and businesses.

A return of peace saw German cultural life return, albeit at a diminished scale. The rise of Nazism would finally sunder links between Chicago's Germans and their ancestral homeland. Unlike World War I, the odious nature of the Adolf Hitler regime found few open defenders among Chicago Germans.

CONFLICTED PATRIOTISM, 1917. For some German American families, World War I forced a self-imposed stripping away of their former nationality. Becoming a patriotic American meant changing Germanic-sounding first and last names and showing visible signs of unyielding loyalty by dress and manner. Pictured is a young German American boy dressed in naval attire waving the American flag.

CSO CONDUCTOR. Frederick Stock became conductor of the Chicago Symphony Orchestra (CSO) upon the death of founder Theodore Thomas. The CSO was known as the Theodore Thomas Orchestra until 1913. Stock felt compelled to step down by anti-German sentiment during World War I. He resumed his duties after the war.

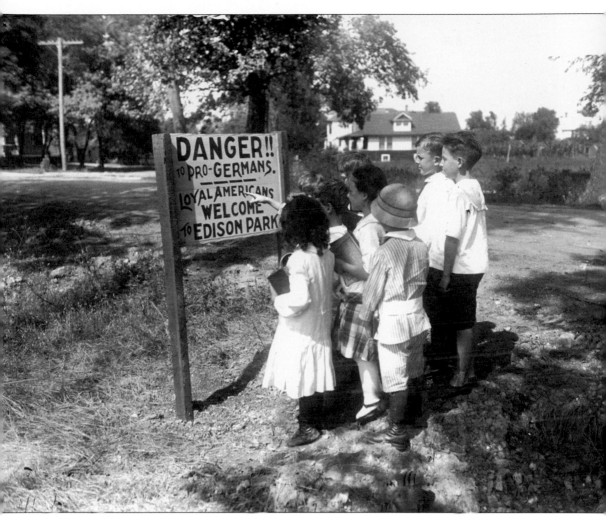

EDISON PARK, 1917. These children are inspecting a homemade sign admonishing German sympathizers to stay away. Soon restrictions that carried the force of law would be enacted. German aliens were prohibited from traveling through areas doing vital war work, including the stockyards, steel mills, and the Loop. (Chicago History Museum, DN-0069264.)

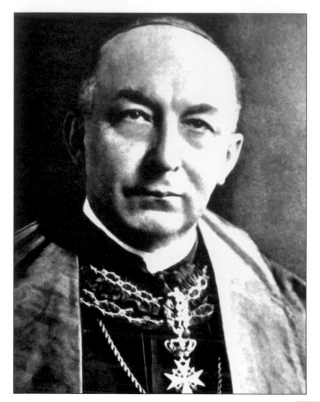

CARDINAL MUNDELEIN. George Mundelein was the youngest man, age 43, to hold the office of archbishop in the American Catholic church. He was frequently at odds with the national churches over his policies of mandatory English instruction in both school and church, which he instituted in 1916. An able administrator, he restructured the archdiocese into a modern, efficient organization. His criticism of Adolf Hitler drew a protest from the Nazi government to the Vatican. The pope chose to commend Mundelein.

U.S. GOVERNMENT BONDS, 1917. Advertisements for Third Liberty Loan drove home patriotism in the form of stressing an allegiance and profession of nationality by purchasing U.S. government bonds. "Are you 100% American?" addressed a growing concern of the enemy living among the people. German-owned businesses would advertise the amount of money they raised for bond drives to demonstrate their loyalty.

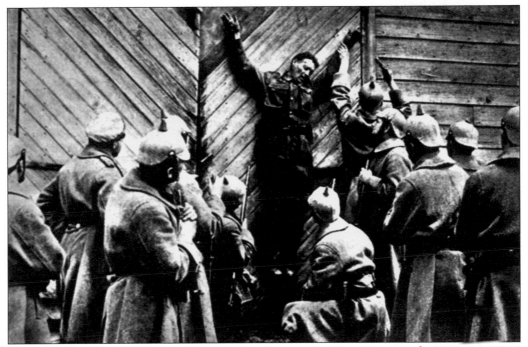

WORLD WAR I PROPAGANDA. Propaganda photographs like this one, showing an Allied soldier being crucified, helped to elevate anti-German hysteria. A vigilante group known as the American Protective League acted as informers and enforcers of what they called 100 percent Americanism. When Otto Heyne refused to wear an American flag lapel pin, he was held by a mob of 30 people who threatened to throw him into the Chicago River. When police arrived, Heyne was arrested and fined.

GRINNELL ADVERTISEMENT, 1914. Even the kaiser was drafted into the American War effort. Grinnell Sprinkler Systems Company admonished readers that factory time lost to preventable fire helped out the German cause. The German government did in fact use agent provocateurs to disrupt war plant production.

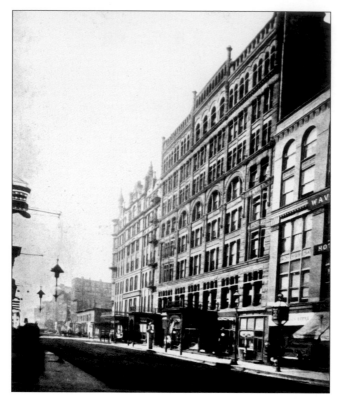

OLD HOTEL KAISERHOFF, 1900S. Located on the west side of Clark Street, between Jackson and Van Buren, the Kaiserhoff expanded, building a new high-rise next door in 1915. The Kaiserhoff then became the Kaiserhoff and the New Annex Hotel.

THE BISMARCK HOTEL, 1920S. Located on Randolph Street at LaSalle Street, this vintage poster for the Bismarck Hotel shows German American entertainment of music and floorshow by Leonard Keller and his dance orchestra. The hotel was owned by Karl Eitel, a prominent German who led a rally in 1914 along with other German civic leaders massing sympathy for Germany from the "barons of the American press." The hotel changed its name to the Hotel Randolph in 1918.

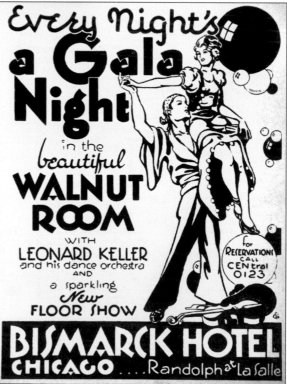

Every night's a Gala Night in the beautiful WALNUT ROOM WITH LEONARD KELLER and his dance orchestra AND a sparkling New FLOOR SHOW

for RESERVATIONS CALL CENtral 0123

BISMARCK HOTEL CHICAGO....Randolph at LaSalle

KAISER BILL. Mayor William Hale Thompson was known as "Kaiser Bill" because of his outspoken opposition to American participation in the war. He so assiduously courted the German vote that he was made an honorary member of the German National Alliance, a lobbying group. He promised to punch the King of England in the nose if ever came to Chicago!

THE LINCOLN CLUB, 1923. Feeling the brunt of public opinion and growing disdain for all things German-sounding or named in the city of Chicago around World War I, the Germania Club felt the need to change its name to more patriotic-sounding Lincoln Club. This photograph, dating December 3, 1923, shows the 18th annual exhibition of the Chicago Branch of International Cooks Association. The club reverted back to Germania Club after the war.

HOTEL ATLANTIC, 1920s. Seeking a more American-sounding name in the face of rising anti-German sentiment, the Hotel Kaiserhoff changed its name to the Hotel Atlantic. Keeping hotel guests and trade show business was paramount to this move in marketing and newly branded hotel identity. This large culinary show displays the new name of the hotel in the background.

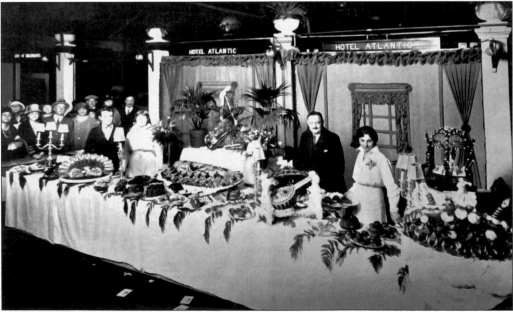

THE BOOK BURNER OF CHICAGO, 1927. Urbine Hermann, part owner of the Boston Red Sox, was appointed to the library board by his friend Mayor William Hale Thompson. A shared love of yachting seems to have been his chief qualification. Mayor Thompson fired his school chief when he refused to remove books deemed too pro-British. The school chief's lawsuit and trial became nationally known as Chicago's Scopes Trial. Thompson announced that he and Hermann would personally review the schools' and libraries' holdings. Hermann promised to burn every offending book. This garnered Chicago the title of "Book Burning Capital of the World," a distinction gratefully ceded to Berlin in the 1930s.

SHEET MUSIC, 1933. For the 1933 world's fair, the Century of Progress International Exhibition, organizers chose an Alpine theme for the German village. In keeping with its theme of modernity, it showcased an outdoor ice-skating rink in summer. A pro-Nazi group was allowed to speak at the opening ceremonies, but fair organizers Otto Schmidt and Willem DeVry, who were Germania Club presidents, threatened them with arrest if they displayed the swastika banner.

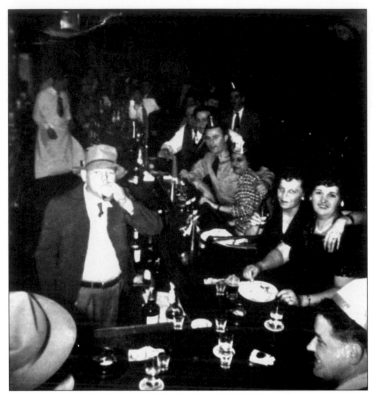

WORLD WAR II NEW YEAR'S EVE. Over 370,000 German prisoners of war were held in the United States during World War II. They were used mostly as agricultural laborers. One German POW, Paul Stachowiak, escaped from Camp Grant near Rockford and ended up in a North Side bar on New Year's Eve. After enjoying the Gemütlichkeit and a few too many schnapps, Stachowiak let his identity slip out and was turned over to authorities by one of the more sober revelers.

REINHOLT PABEL, 1940. Reinholt Pabel was an Africa Corp veteran who was captured and sent to a POW camp just outside Joliet. Pabel escaped in 1945 carrying in his possession a magazine article by J. Edgar Hoover on how the FBI catches escaped POWs. Under the assumed name Philip Brick, Pabel obtained a job washing dishes in a Chicago restaurant. Moving on to various jobs, including one at the *Chicago Tribune*, Pabel eventually opened a used bookstore on the North Side. (Pabel family collection.)

MOBILE BOOK STAND, 1960s. Based on the interest from the magazine articles, Reinholt Pabel wrote a memoir of his POW experiences. Titled *Enemies are Human Too*, the book was published and distributed in four languages. He is shown here with his stand at a German American organization to which he belonged. Moving back to Germany in 1967, Pabel ran two antiquarian bookstores in Hamburg until his death in 2008. His book is set for rerelease by the University of Illinois in 2009. (Pabel family collection.)

CHICAGO BOOK MART, 1965. Reinholt Pabel ran a bookstore at 1021½ West Argyle Avenue. Marrying a local Chicago girl, they started raising a family. In 1952, he was finally apprehended and taken into custody by the FBI. His story was featured in several national publications. He was forced to leave the United States for six months and then reenter legally. (Pabel family collection.)

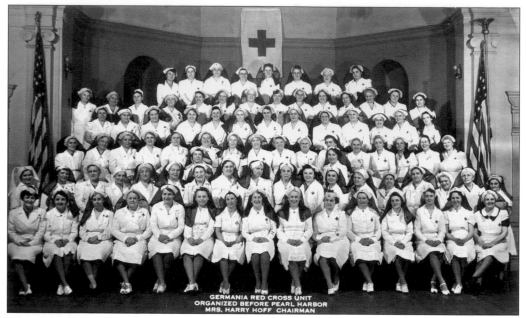

WOMEN'S GERMANIA RED CROSS UNIT, 1944. Still sensitive from World War I suspicion about loyalty to the United States, many German American associations demonstrated their patriotism through public service. The Women's Germania Red Cross Unit was organized prior to the bombing of Pearl Harbor. Focusing on humanitarian efforts such as preparing bandages and care packages and answering soldiers' letters, they displayed their loyalty to country through compassion and dedication to service within their community.

LAURINAITIS FAMILY. A war-torn World War II Lithuanian family found their way across Poland and Germany. Never being allowed to settle, or to safely put down roots, four of the Laurinaitis children were born in three different displacement camps in Germany. With the children now holding German passports and papers, this photograph dated 1950 shows the family leaving by rail for a waiting U.S.-bound ship in Bremen. Sponsored by a Chicago relative, the family would immigrate to Bridgeport. (Laurinaitis family collection.)

Seven

GERMANIA AND OTHER CLUBS

Chicago in the 1880s was a place where one could be free from conscription, be educated, live comfortably, and make a good wage. Often though, when Germans arrived to the fast-paced city, they found harsh conditions, overcrowding, and little to no jobs. Banding together with other German language speakers, most sought guidance from those who had already maneuvered the immigration route. Dialects and customs of the varying regions of Germany encouraged specific groups to gather, forming clubs on the basis of special interests, specialized trades, and even those whose functions were primarily philanthropic. The German Club, or Verein, became the active social and networking function of the German community. Singing groups, shooting groups, and aid societies cropped up within the city, immersing the German immigrants in the traditions and rituals of their homeland.

In 1852, the first Turn Verein, Chicago Turngemeinde was founded in the city. Based on Friedrich Jahn's beliefs, summarized as "a sound mind in a sound body," Turnerism provided its members with a meeting place that encouraged physical activity along with mental development. Impressed by the Turner ideal, German political 1848 revolution exile Chicago School Board president Lorenz Brentano implemented this method in a west side public high school in 1866.

Pres. Abraham Lincoln was an ardent supporter of the Turner ideal. Lincoln courted the growing German vote by appointing influential German supporters to high office. Chicago *Staadts Zeitung* editor Georg Schneider was appointed ambassador to Denmark, while Carl Schurz, a Civil War general, was appointed ambassador to Spain. The Germans' devotion to the Unionist cause led to a deep affection for this president. Greatly shocked by the assassination, German singing groups met at the Lincoln casket and sang dirges to honor the martyred president. This was the founding of the Chicago Maennerchoir. They would later evolve into the Germania Club, the most prestigious of the German private clubs.

With urban renewal coming to the old town neighborhood, and changes in social tastes, Germania's membership slowly dwindled until it disbanded in 1986. Television and post–World War II leisure society made participation in private clubs less appealing to younger German Americans. The roughly 500 clubs founded by Germans has now dwindled to a handful. The most recent demise has been the Schiller Liedenthall Verein, one of what was hundreds of singing clubs, which ended its 134-year existence in December 2008.

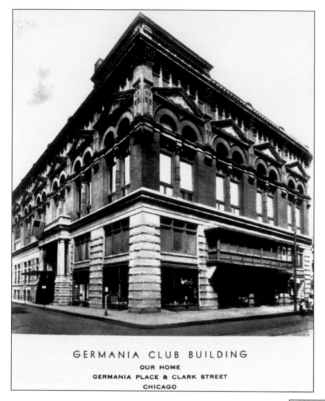

GERMANIA CLUB BUILDING
OUR HOME
GERMANIA PLACE & CLARK STREET
CHICAGO

GERMANIA CLUB EXTERIOR. The Germania Club was located at 108 West Germania Place. Designed by architect August Fiedler in 1888, the building saw many dignitaries to the building, including Richard Strauss, Jack Dempsey, Albert Einstein, Max Schmeling, and many others.

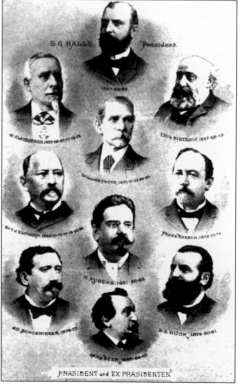

EARLY GERMANIA PAST PRESIDENTS. Early Germania presidents included German and German American movers and shakers of the city. Highly connected past president Gustavas Claussenius was the son of the Austro-Hungarian consul. After working in his father's bank for numerous years, he developed his own ocean steamship passage business at 76 LaSalle Street in 1883.

HARRY RUBENS. Born in Vienna, Austria, Harry Rubens served as club president of the Germania Club. A private secretary for Carl Schurz from 1871 to 1872, journalist, and attorney, this multitalented man was pivotal in bringing many different personalities to the club. Decorated by the emperor of Germany with the Order of the Crown in 1902 and with the Order of the Iron Cross from the emperor of Austria in 1907, Rubens's finest moment was when he delivered a speech in German at Schurz's memorial. With a personal letter from Theodore Roosevelt, Rubens delivered the moving speech downtown at the packed Auditorium Building to the mourning German public. (Chicago Public Library, Sulzer Regional Library, Historical Room.)

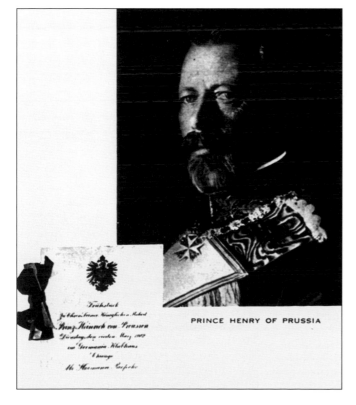

PRINCE HENRY OF PRUSSIA

PRINCE HENRY OF GERMANY. One of the most lavish dinners ever thrown in Chicago history was one given by the Germania Club. Honoring the visit of Prince Henry of Prussia in 1902, the club spent over $20,000 entertaining the kaiser's brother. The other highlight of the prince's visit was his sojourn to the notorious Everleigh Club, where the prince allegedly began the custom of sipping champagne from a lady's shoe.

GERMANIA INTERIOR. An interior view of one of the many rooms of the Germania Club, this photograph features two stained-glass panels on either side of the fireplace. Used as a club or card playing room, the decor boasted red leather club chairs, wood paneled walls, and "Gasthaus-style" chandeliers.

KURT MEYER'S SCHLACHTFEST, 1952. Lavish and extraordinary dinners were commonplace at the Germania Club. This particular dinner included succulent roasted young pigs and a turn-of-the-century vogue food item of dressed pig heads. Prepared by leading chefs, the featured courses were extravagant and unique.

XI Berlin Oylmpic Menu, 1936. Germania Club members had the luxury of purchasing group travel packages as part of their membership. This menu from the 1936 Olympics held in Berlin was the final destination of a multistop German city tour package. Conscious of world opinion, the Nazis relaxed and hid their discriminatory policies during the games as they welcomed outsiders to the competition.

JACK DEMPSEY. Among the many celebrities hosted by the Germania Club was prizefighter and heavyweight champion of the world Jack Dempsey. A close friend of club president William (W. C.) DeVry, Dempsey is shown here with another Germania club member, noted muralist Martin E. Zeigner. Zeigner presented "the Manassas Mauler" with a drawing of the champ's famous fighting stance. Dempsey held the heavyweight title from 1919 to 1926.

GERMANIA CLUB
108 GERMANIA PLACE
CHICAGO·

General Membership Meeting – Dec. 17, 1958

Application for Membership

Application No._____

<div>
Membership Com. ✓
Membership No._____
Admissions Com. ✓
Board _____
Birthday ✗ | By-Laws ✓
Occupat'ns ✗ | Roster ✓
Membership Certif ✓
Plate ✓ | List ✓
Card ✓ | A.M. ✗
| M ✗
A ✗ | D ✗
</div>

DATE **11/29/58**

NAME *May Schmeling*

I hereby apply for a _____*Honorary*_____ membership in Germania Club, a corporation not for profit, created and existing by virtue of a special charter issued by the State of Illinois on March 31, 1869, in pursuance of a Special Act of the Legislature of said State and agree to abide by all its laws, rules and regulations.

I am a citizen of the United States and either of German birth or descent as stated on back hereof.

I make answers to the questions on the back hereof which I affirm to be true.

[signature]
(Signature of Applicant)

Hollenstedt
(Address where mail is to be sent.)

Sponsored by *W. C. DeVry*
(Member of Club)

Krs. Harburg Germany

MAX SCHMELING, 1958. Some honorary memberships were given out to dignitaries and personalities who visited the Germania Club. This honorary membership, sponsored by club president W. C. DeVry, founder of DeVry Technical Institute, presented Max Schmeling as an applicant before the general membership committee on December 17, 1958.

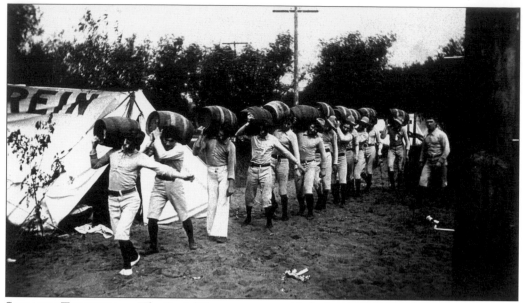

SOZIALEN TURNVERINS. The Social Turners were established in 1887 and would meet at Rachau's Hall at Lincoln and Fullerton Avenues. With 46 different German clubs meeting at the hall, the expanding Social Turners found new residence at Belmont and Paulina Avenues. The Social Turners pictured here are on a retreat. Believing that a sound mind means a sound body, the young Turners carry enough beer to quench the thirst of their fellow campers. (Chicago Public Library, Sulzer Regional Library, Historical Room, RLVCC 4.12.)

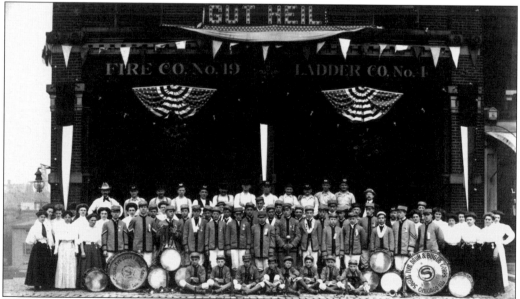

SOCIAL FIFE, DRUM AND BUGEL CORPS, 1909. An offshoot of the Social Turners, the Social Fife, Drum and Bugle Corps, an all-male band, would participate at local and neighboring community parades and functions. A competitive event among the Vereins, each corps was known for its precision in dress and performance. Some bands traveled great distances, as did the Social Corps, pictured here in front of a fire station in Cincinnati. (Chicago Public Library, Sulzer Regional Library, Historical Room, RLVCC 4.5.)

GERMAN-AMERICAN ANTI DEFAMATION LEAGUE. Numerous historical photographs and artifacts are housed at the DANK-Haus. This particular photograph from the 1970s shows Willy Scharpenberg combating negative public portrayals of Germans in the media.

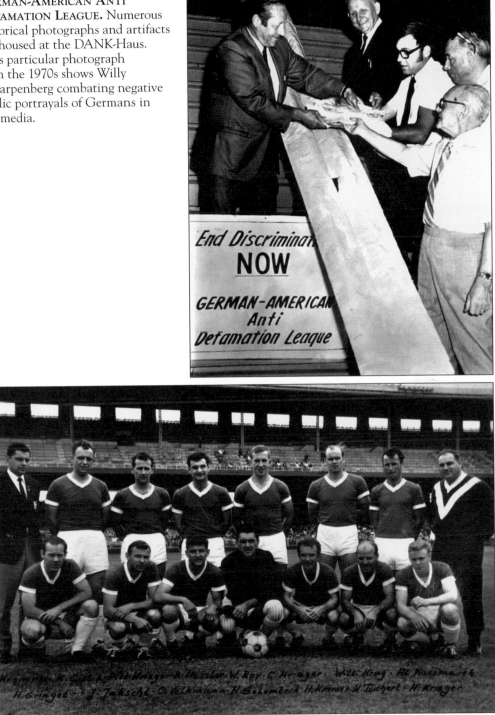

F. C. HANSA CHICAGO, 1965. Many of the Verein also had sports clubs, which were organized into intramural leagues. Soccer was by far the favorite. Here a championship team poses for a photographer. This club has since disbanded.

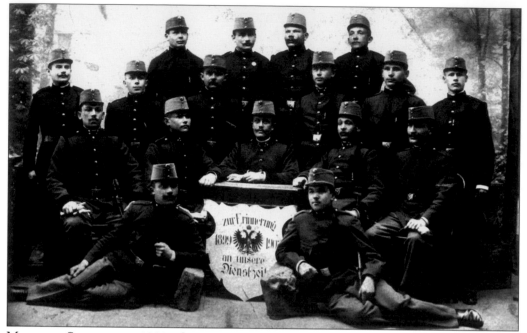

MILITARY SERVICE, c. 1902. Conscription in Germany meant that all young men served seven years in military service. With war and conflict ever present, duty to country and fatherland were expected and enforced. Military remembrances and military clubs became popular both in Germany and the United States, serving the need to be near comrades with shared experiences.

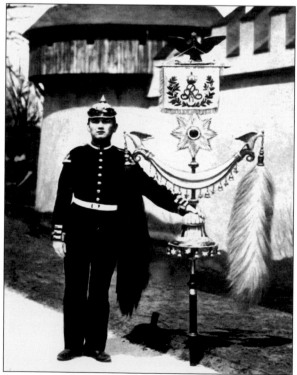

SCHELLENBAUM, 1893. Originating in Turkey, the Schellenbaum was a percussion instrument used in military parades. This instrument was introduced to Germany during the final years of the Habsburg Wars. The Schellenbaum was played and paraded with an infantry unit as it was used to keep time, being struck on the first beat of every measure as they marched. This Schellenbaum is from the World's Columbian Exposition and is currently on display at the DANK-Haus, German American Cultural Center Museum.

UMZUG, RIVERVIEW PARK, 1954. The world war veterans are pictured here in a memorial parade at Riverview Amusement Park. The club carries the German flag, United States flag, and the city of Chicago flag along with the club's flag. The new marchers are recently immigrated German soldiers from World War II.

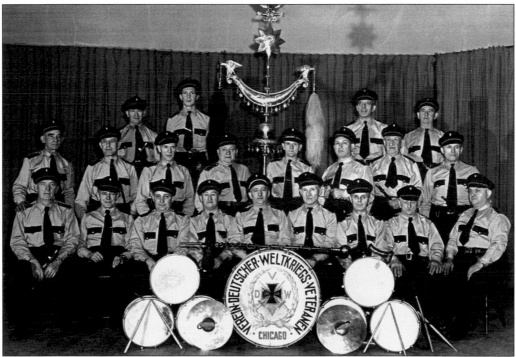

WORLD WAR VETERANS GROUP, 1950s. Pictured are club members of the Verein Deutscher Weltkriegs Veteranen des Chicago, a fraternal men's veterans organization. They are posed with their silver standard, first brought to Chicago for the World's Columbian Exposition in 1893.

FRAUENGRUPPE, 1970. Dedicated to service and committed to all fund-raising aspects, the Frauengruppen, or ladies group, sell handmade Christmas gifts for the DANK Kinderschule at Pullman's Bank. This photograph dates from the 1970s, with Mayor Jane Byrne. Although not officially disbanded, some of its members still commit to volunteering by guiding the next generation in tradition and service to DANK.

VON STEUBEN PARADE IN FRONT OF MARSHALL FIELDS, 1969. Originally a downtown parade, the von Steuben Day parade, or German Day parade, holds representatives of most local German Verein, or German clubs, in the Chicagoland area. These marchers are walking in front of the old Marshall Fields department store located between Lake and Washington on State Street.

Eight

"REPORTS OF MY DEATH ARE GREATLY EXAGGERATED"

As one after another longtime German establishment closed their doors in the late 1980s and 1990s, it appeared that Chicago would soon lose any trace of its German footprint. German cuisine was seen to be passé, and as venerable mainstays such as the Golden Ox, Zum Deutschen Eck, and Heidelberger Fass went out of business, the obituary for the German Chicago restaurant was being written.

Like Mark Twain's character, there was more life in the body than originally thought. Unexpectedly, many new German restaurants opened, including several in the ultratrendy Wrigleyville neighborhood. The Julius Meinl stores reacquainted Chicagoans with the concept of Austrian cafés. The city began hosting an outdoor Christmas market, Christkindl Market, featuring vendors from Germany. It is very popular and well attended, becoming something of a new Chicago Christmas tradition. Each fall, the number of neighborhood Oktoberfests proliferates. Lincoln Square has introduced a traditional spring festival called Maifest. Even beer is being brewed in Chicago again, although not necessarily by German firms or on the scale that it once was.

The alderman of the 47th Ward, Eugene Schulter, has made a concerted effort to maintain Lincoln Square's ethnic flavor. He was instrumental in bringing a section of the Berlin Wall to Chicago, installed within the Western Avenue, Brown Line El stop.

The venerable DANK-Haus was saved from sale, is being resuscitated, and has been turned into a German American Cultural Center. It is host to an art gallery, German language school, German clubs, German films, and concerts. Many of the artifacts featured in this book are on display in a newly opened museum. The DANK-Haus is actively seeking additional artifacts for preserving the 150-year German presence in Chicago. The DANK-Haus is currently cataloging, archiving, and restoring its collections, introducing an old story to a new generation.

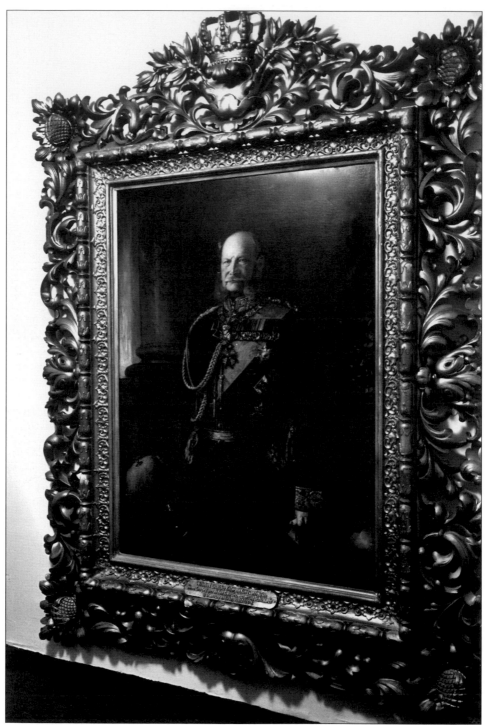

KAISER WILHELM I, 1871. This oil painting on panel was a gift from Kaiser Wilhelm I to U.S. ambassador to Berlin and historian George Bancroft for his service and friendship with the German people. The painting now resides at the DANK-Haus, German American Cultural Center on the North Side. The painting is set for restoration in 2010.

HAROLD WASHINGTON, 1983–1987. Although there is no German voting block, politicians still find it advisable to court German voters. Here Mayor Harold Washington charms the Frauen at a German event.

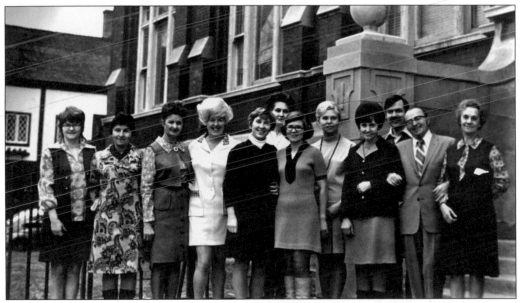

DANK NORD SCHOOL. Seen in the late 1960s are German-language DANK North teachers. In the distance is now-defunct German restaurant Zum Deutschen Eck. Standing on the steps of the athenaeum, which now serves as a performing arts center next door to St. Alphonsus Church, the DANK North language teachers have relocated the German-language school to the third floor of the DANK-Haus, German American Cultural Center, at 4740 North Western Avenue.

DANK KINDERSCHULER, 1970. DANK North German Children Language School was held at St. Alphonsus School and later moved to the third floor of the DANK-Haus, 4740 North Western Avenue. Holding German-language classes on Saturday, the school remains vital and active, holding instruction to children 3–14 years old.

SCHILLER LIEDERTAFEL BANNER. This popular singing group, founded in 1877, ended its century-long tradition of performing in the Chicago area in 2008. The many treasured archives, such as this silk banner, are currently available for viewing in the Lost German Chicago Exhibition. This banner along with other records shows the progression and vitality of the group through the ages.

DANK-HAUS CHRISTMAS TRADITION. Hosting Christmas events for numerous German Clubs since 1967, the tradition still lives on today. This photograph from 1968 shows Santa greeting all good boys and girls. Chocolate candy is normally given; however, this baby is receiving German-language flash cards.

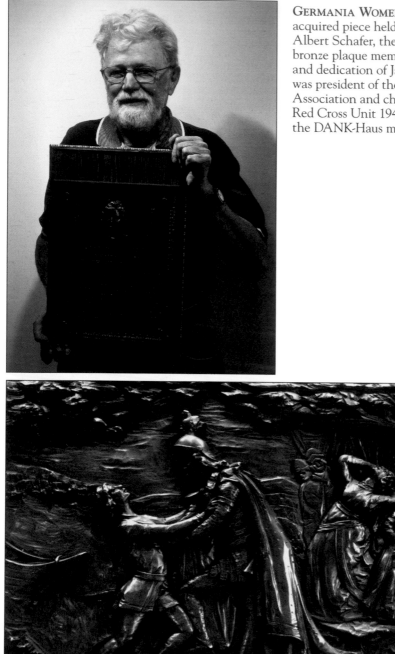

GERMANIA WOMEN'S PLAQUE. A newly acquired piece held by DANK archivist Albert Schafer, the Germania Women's bronze plaque memorializes the service and dedication of Jane Haas Hoff, who was president of the Germania Women's Association and chair of the Germania Red Cross Unit 1941–1946. It remains in the DANK-Haus museum and collection.

THE WAGNER CARVINGS, c. 1890. Originally gracing the walls of a Logan Square mansion, the hand-carved Wagner carvings, depicting various Wagner operas, were purchased and installed at the Germania Club in 1961. The wood panels are carved from single 18-inch-wide boards, some 11 feet long. The panels are now installed in the new museum of the DANK-Haus, 4740 North Western Avenue.

SCHELLENBAUM BELL. This close-up of the Schellenbaum from 1893 displays the intricate casting of weighted bells. In beautiful condition, the military musical instrument has been passed down from the original Franco-Prussian War veterans to the German World War I veterans group. Used in parades up until the 1950s, the Schellenbaum now rests in the DANK-Haus museum in the Lost German Chicago exhibition.

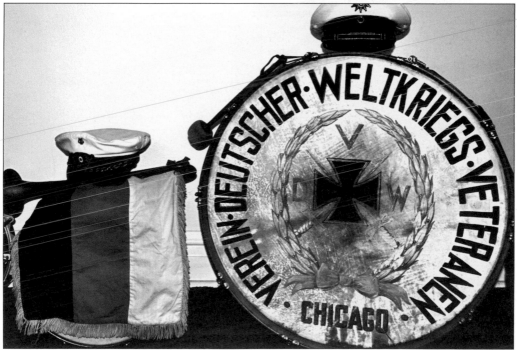

DRUM AND BUGLE. Bearing drum and bugle, the World War Veterans Club continued to meet and parade at Riverview Amusement Park. This drum and bugle from the World War I Veteran Club can be found in the DANK-Haus museum, along with other artifacts and photographs of the group.

THE SCHARPENBERG GALLERY. Located on the fourth floor of the DANK-Haus, the Scharpenberg Gallery hosts local and international artists. Featuring fine art exhibitions, the gallery commands high-quality art venues along with astounding views of the downtown skyline. Art patron and past DANK president Willy Scharpenberg envisioned a cultural center that promoted the arts, education, and community outreach. The gallery, bearing his name, celebrates its fourth year in the community. (Karen Page photograph.)

THREE LINKS LODGE. The former German Odd Fellow lodge, the Three Links Lodge, was erected in 1927 at 4740 North Western Avenue. During World War II and even up until the late 1960s, the building was used as an SRO, or single resident occupancy hotel. In 1968, DANK Nord, DANK North Chapter purchased the building. Remnants of the old lodge are found throughout the building, such as the Masonic "all seeing eye," with three link door knobs in the Marunde Ballroom on the fifth floor.

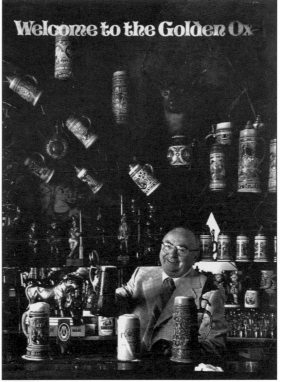

GOLDEN OX AND MATT SCHULIEN.
These two restaurants, once blocks
away from one another, represented the
German tradition of Gemütlichkeit,
where good times, good food, and good
cheer were exemplified. Both closed
now, the tradition lives on in images
and memories. Raised glass, warmth
in a smile, they both wished a toast of
cheer—Prost!

www.arcadiapublishing.com

Discover books about the town where you grew up, the cities where your friends and families live, the town where your parents met, or even that retirement spot you've been dreaming about. Our Web site provides history lovers with exclusive deals, advanced notification about new titles, e-mail alerts of author events, and much more.

Find Your Place in History.